RAILROADS
IN EARLY POSTCARDS

VOLUME ONE UPSTATE NEW YORK

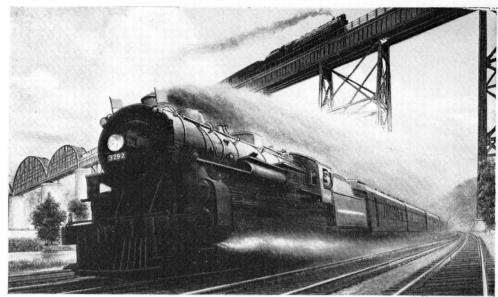

THE TWENTIETH CENTURY UNDER THE CASTLETON CUT—OFF BRIDGE.

The famous Twentieth Century Limited was inaugurated by the New York Central Railroad on June 15, 1902, providing service between New York City and Boston in the East and Chicago in the mid-west. At one time, the scheduled time between New York and Boston was as low as 15 hours, in the mid-1930's . . . a time far less than taken by Amtrak, a half century later. This postcard is from a painting by Walter L. Greene titled "The Twentieth Century Limited—A National Institution." It was made in 1925 and shows the train storming toward New York City along the Hudson River just south of Albany. The train operated until 1967.

At one time Summitville was a busy junction point for the main line of the New York, Ontario, and Western Railway and its branches to Kingston and Port Jervis. From Summitville to Kingston, the railroad followed the Rondout river for 36 miles through a valley rich in cultural heritage dating to many years before white men arrived on the scene. It was an area where it was not uncommon to find Indian artifacts merely by tilling the ground. The card was mailed in 1909.

From a topographical standpoint, "Summitville" is a misnomer. The community lies in a valley and the railroad was often obliged to use "helper" engines to assist trains in getting up the stiff grades to outlying regions.

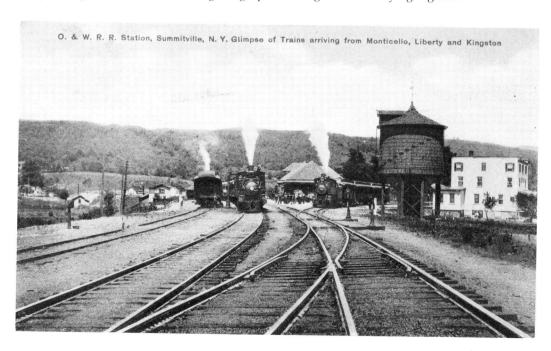

O. & W. R. R. Station, Summitville, N. Y. Glimpse of Trains arriving from Monticello, Liberty and Kingston

RAILROADS
IN EARLY POSTCARDS

VOLUME ONE UPSTATE NEW YORK

by
Richard Palmer
and
Harvey Roehl

The Vestal Press Ltd.
Vestal, New York 13851

Library of Congress Cataloging-in-Publication Data

Palmer, Richard, 1941–
 Railroads in early postcards / by Richard Palmer and Harvey Roehl.
 p. cm.
 Contents: V. 1. Upstate New York.
 ISBN 0-911572-87-2 (v. 1 : alk. paper)
 1. Railroads—New York (State)—History—Pictorial works.
2. Postcards—New York (State)—History. I. Roehl, Harvey N.
II. Title.
TF24.N7P35 1990 89-70721
385'.09747'022—dc20 CIP

First printing—1990
© 1990 by The Vestal Press Ltd

*For additional copies of this book or a
complete catalog, write to*

The Vestal Press Ltd. PO Box 97
Vestal 79 New York 13850 USA

INTRODUCTION

My heart is warm with the friends I make
and better friends I'll not be knowing.
Yet there isn't a train I wouldn't take
No matter where it's going.

Edna St. Vincent Millay wrote these well-remembered words in 1921, capturing the essence of the romantic side of train travel. Mysteries of far-away places, new friendships to be made along the way, scenes to be observed as the train speeds down the tracks—all make up a vision of the delights of travel by the iron horse on steel rails.

She wrote these lines near the end of the golden age of train travel in America. Not much later, the convenience and freedom of the affordable family car pulled passengers out of the coaches and Pullmans, and a short three-and-a-half decades later passenger service had all but vanished across the land. Were it not for the quasi-government agency Amtrak, all intercity train travel would be gone by now, thanks to the economic realities of our times.

During the two decades before Edna St. Vincent Millay's poem was written, a postcard craze swept the country. Picture postcards got their start in the early 1890's; in the first few years of the 20th century, nearly everyone was engulfed in the fervor of sending pictures with messages written to friends and kin. In 1907 the U.S. Postal Service, in a helpful mood, relented, letting writers put their message on the back of the card, rather than requiring them to confine their notes to a small space on the margin of the card's face. The Post Office was delighted to deliver a card to any address in the entire United States for a mere penny! This was a time when the only practical means of long-distance overland travel was by train. Since practically no machine that mortal man has ever devised is as photogenic as the iron horse and its cars—together with its bridges, buildings, and other structures along the right-of-way for the track—countless thousands of railroad scenes have been featured and thus preserved on postcards.

Today these views are avidly collected not only by postcard enthusiasts, but especially by railfans who thrill to the scenes of a vanished era. They wonder, as do many, if we were really so smart to abandon much of the vast network of some 230,000 miles of track once existing across America, now that the automobiles we love and airplanes and airports that have served the traveling public very well are creating problems of their own. In 1923 there were some 23,000 inter city train movements a day in the country; at this writing, there are something like 600.

But philosophical and economic questions aside, it's enjoyable to look back at a time when travel was a bit more leisurely, and when life seems—at least in retrospect—to have been somewhat simpler than the "rat race" we call it today. Postcards capture the era as it was at the time the pictures were taken and not what we think it was like. They are a true historical picture of the scenes they depict.

The truest ones are the "photo cards" taken by a local photographer of some special scene like a wreck, fire, or some other disaster, or perhaps a special local feature of the road not deemed of enough interest for a large card publisher and distributor to produce it in substantial quantities. These cards were printed directly from the photographer's negative on special "post card" paper available from Eastman Kodak, Ansco, and other suppliers of photographic materials, and were sold mainly in local outlets. As a result, these cards were made in the smallest quantities. This, in turn, means that they are usually the most valuable and collectible cards.

Readers of this book are encouraged to recognize that it is simply a collection of interesting scenes selected randomly from around the state; the writers make no pretense that it's any kind of definitive history of the railroads themselves, the regions, or the communities served by the rails. They have tried to provide a bit of historical information for each of the scenes—more for some than for others—in an attempt to add interest. Their main objective has simply been to show some views of an important facet of everyday life in the early days of the century.

We'd like to think that Ms. Millay would have enjoyed it.

Richard Palmer
Harvey Roehl
1989

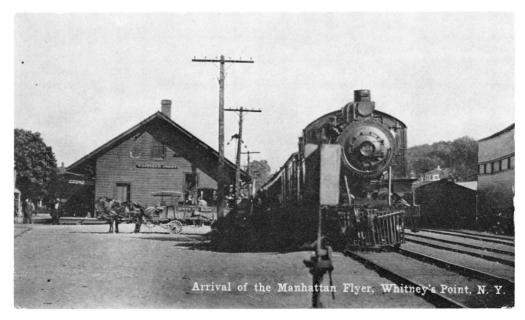

Arrival of the Manhattan Flyer, Whitney's Point, N. Y.

Almost until the time passenger service was discontinued on the Syracuse branch of the Lackawanna Railroad in 1957, through service was available between Syracuse and New York City. Here the *Manhattan Flyer* pauses at Whitney Point. This wooden station was replaced by a brick structure in 1904.

Acknowledgements and Credits

This book is based mainly on the extensive postcard collection and descriptions of Richard Palmer, a long-time student of railroad matters. Harvey Roehl has contributed commentary and in so doing is considered the junior author. Mr. Roehl and his wife Marion founded The Vestal Press in 1961, and retired from full-time responsibility in 1989.

The authors and publisher especially appreciate help from other sources. Valuable cards were loaned by Adam Perl, Bill McCord, Tom Richardson, and William Swart. Bob Brennan supplied helpful information; John J. Young, Jr., Bill Kalbaugh, Henry Clark, and Herb Trice made significant contributions by their critical reviews of the text. Shelden King, Bob Struble, Allan Jackson, and Chuck Yungkurth assisted by loaning reference material and offering welcomed advice from time to time. We've tried not to forget anyone who helped!

Lucie Washburn did a very thorough job of editing and polishing grammatical points.

This is one of a series of books based on regional and topical postcard collections that The Vestal Press has produced; proposals by interested postcard collectors and enthusiasts for future books based on this format are most welcome.

Grace L. Houghton
Publisher
The Vestal Press Ltd.

Until the 1930's, the citizens of Syracuse had more railroading in their city than many of them wanted, for the New York Central passenger trains went right through the center of downtown on Washington Street. The West Shore Railroad did the same about four blocks to the north, and the Lackawanna went north and south to add to the confusion.

Typically there were between 60 and 125 train movements a day in the downtown area, and guards had to protect some 29 grade crossings.

Engineers on the *Empire State Express* were obliged to proceed no

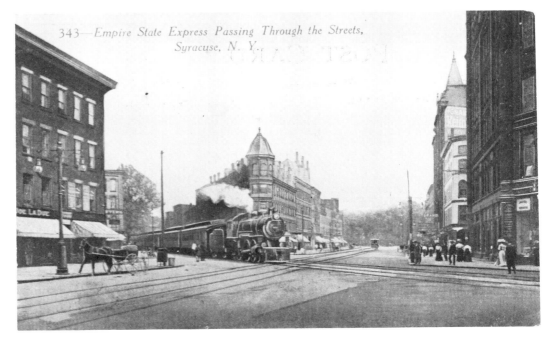

343—Empire State Express Passing Through the Streets, Syracuse, N. Y.

faster than eight miles per hour. When streets were as free of traffic as in this picture, the trains were tolerable, but when Mr. Ford's tin lizzies and the products of Detroit's other factories started to fill the streets, the urban gridlock got to be a bit much. A massive relocation project in the mid-1930's eliminated the frequent nuisance of interruption to motor car traffic and conveniently shifted the soft coal smoke elsewhere for others to breathe.

The famous Hotel Yates is seen on the right in this early 1900's view.

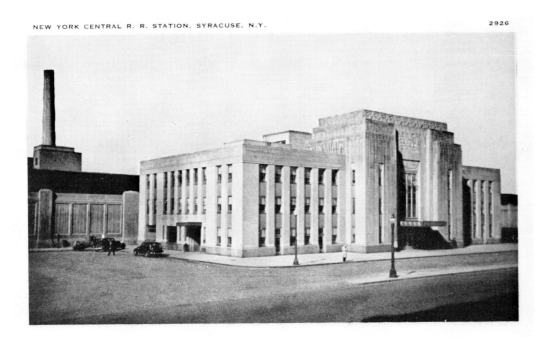

NEW YORK CENTRAL R. R. STATION, SYRACUSE, N.Y. 2926

This new and beautiful Art-Deco-styled station of the New York Central Railroad was part of the relocation project. It opened in September, 1936 on Erie Boulevard just east of the main business section of town and not only served patrons of the road, but also housed its division offices. A noteworthy feature was a fine bas-relief on the front of the structure depicting the early *DeWitt Clinton* and the *20th Century Limited*, the outstanding named trains of their day.

It took nearly five years to build the "elevation" through the city; it generally followed the alignment of the old West Shore Line tracks. This building was used as a station until 1962 when a new depot was built in East Syracuse, now served by Amtrak. Since then the structure has served as a bus terminal.

It saw heavy use during World War II, and one of the authors has pleasant memories of the building during that era. Forced to wait many hours one night during his Air Force service to make a train connection after a furlough spent in Ithaca, he was able to take advantage of a free bunkroom for some much-needed sleep. Local townspeople, anxious to make life as pleasant as possible for members of the military establishment, provided this greatly-appreciated service.

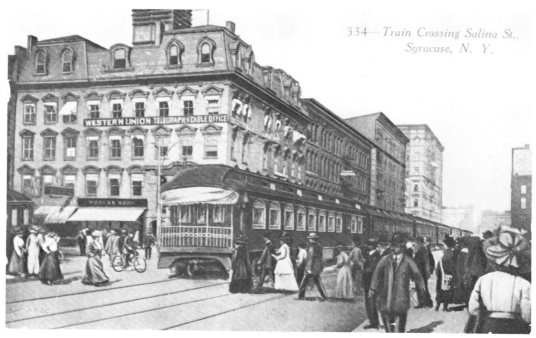

334—Train Crossing Salina St.,
Syracuse, N. Y.

The passing of a train through downtown Syracuse seems to be an everyday occurence to these pedestrians who appear unimpressed by the presence of an open-ended observation car. Careful inspection of the picture, however, suggests that an artist has retouched the photograph of an ordinary railroad car, adding an awning and a railing to make it look like it really had a brass-railed observation platform.

The mansard-roofed building in the background at the corner of Washington and Salina Streets is the Syracuse House—well-known hostelry of the day that housed, in addition to its transient guests, the local offices of the Western Union Telegraph Company.

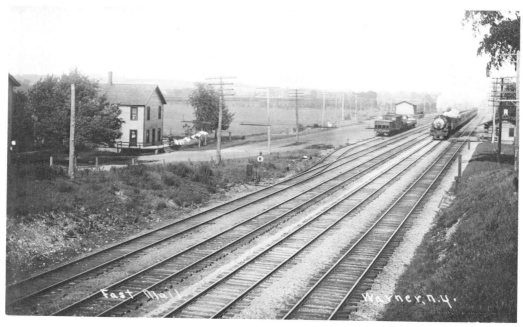

Warners (spelled Warner on the card) is about 10 miles west of Syracuse on the New York Central mainline; extensive brickworks were once located in the community. Fortunately for the housewife whose laundry flaps in the breeze as the *Fast Mail* train approaches the engine is on the downwind side of the house on this day. It seems logical to assume that she, as did many others like her who lived adjacent to railroad tracks in the days when soft coal provided the energy to drive the iron horse, learned to take proper precautions to protect her wash from frequent dusting with black soot.

New York Central's 474 miles of main line featured four tracks extending from Castleton, New York, to Collinwood (near Cleveland), Ohio.

The famous *Empire State Express* was inaugurated in 1893 by the New York Central Railroad to provide superior service between New York City and Buffalo. Prior to 1920, the *Empire* was pulled by these high-wheeled 4-4-2 Atlantic-type locomotives.

The Official Railway Guide for 1930 tells us that the train operated as No. 51 westbound and No. 50 eastbound, and that accomodations included an observation and parlor cars, a dining car, and coaches. Convenient connections could be made to Toronto, Montreal, Lake Placid (except on Sunday),

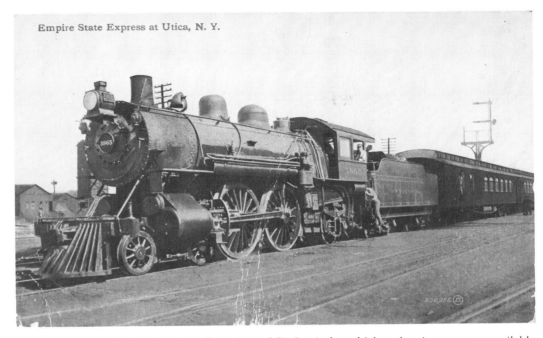

Empire State Express at Utica, N. Y.

Clayton (via Rome), which served the Thousand Islands region; Detroit, and St. Louis for which a sleeping car was available.

Westbound travelers left New York City at 8:30 A.M. and arrived in Buffalo at 5:25 P.M. 535 minutes later, which figures to an average speed of 49 miles per hour to cover the 435.9 mile distance. The eastbound train left Buffalo at 1 P.M. and arrived at Grand Central Terminal in New York at 9:30 P.M., a total of 510 minutes. The 25-minute longer time required for the western trip was occasioned by the presence of West Albany Hill, a stiff grade just west of Albany that required a helper engine to move the heavy trains typical of the day. The extra time represents the slow drag up the slope, the time required for coupling and uncoupling the second engine, and a few moments for testing the air brakes before the *Express* could be off on its merry way to Utica, the next stop to the west.

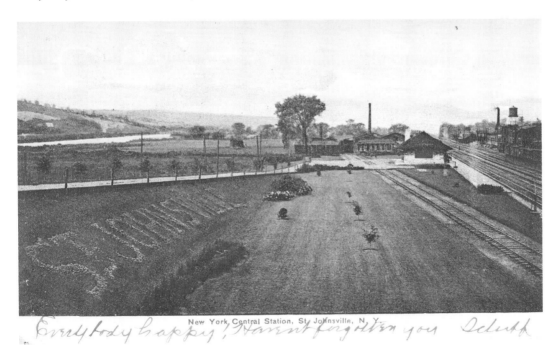

New York Central Station, St. Johnsville, N. Y.

Everybody happy! Havent forgotten you Deluth

It was common practice in the early days of railroading for the roads to spend money to have pleasantly landscaped grounds adjacent to the stations, and this scene of St. Johnsville in the Mohawk River valley is an excellent example. Note the floral design spelling the community's name on the embankment.

The New York Central's four-track main line on the right was extolled in company literature and time tables as "The Water Level Route—You Can Sleep", somehow implying that one could not snooze while patronizing a competitive system such as the Pennsylvania, which was obliged to cope with the Allegheny mountains on its route between New York and Chicago.

St. Johnsville was the home of several industries, notably the Peerless Piano Player Company. Its factories are seen in the far right. The firm was founded by Frederick Engelhardt, a former superintendent in the action department of the Steinway Company in New York City. It was the first company in America to produce a coin-operated player piano (1898) for use in public places such as railroad stations, saloons, billiard parlors, and the like. Until the firm failed in 1915 for reasons not completely clear to those who have studied the case, as many as 300 employees produced instruments in a variety of styles. Many "orchestrions" (an automatic piano fitted with organ pipes, drums, traps, and other musical attachments simulating a small orchestra, usually fitted within a very fancy case with stained glass windows in its doors) were built here and are highly-desired collector's items these days.

3

West Winfield was an important station on the Richfield Springs branch of the Lackawanna Railroad. This station was built in 1901, and an agent was on duty here until 1963. The Delaware, Lackawanna, and Western Railroad enjoyed the reputation of being considered by many authorities as mile for mile, the most highly developed railroad in the nation. This substantial wooden structure would seem to support that contention. The Richfield Springs branch of the

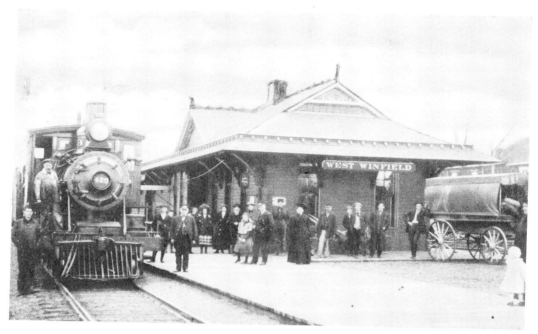

Lackawanna was a 22-mile-long spur running eastward from Richfield Junction, which was 13 miles south of Utica on the Binghamton-Utica line.

The village had several tanneries, as well as feed, fertilizer, coal and lumber dealers, befitting an agricultural area in the early days of the twentieth century. Motorists old enough to have travelled on U.S. Route 20 in the 1930's may recall a famous billboard announcing that one of the drugstores in the town was the "Home of the $50,000 Chocolate Soda." Since Route 20 was an important artery of commerce and the main road between Boston and Chicago before the construction of the Massachusetts Turnpike and the New York State Thruway lots of motorists had the opportunity to speculate on just what bizarre logic was behind this claim.

Phoenix, on the New York Central's Syracuse-Oswego branch 13 miles north of Syracuse, boasted a highly utilitarian station with living quarters on the second story for the agent and his family. This certainly minimized his commuting time "to and from work."

At one time Phoenix had numerous local industries, including papermills. Passenger service on this branch was discontinued in 1951; Conrail later continued using the line to serve Fulton and Oswego.

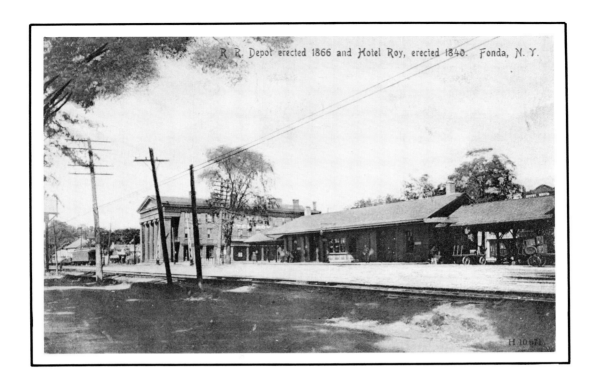

Historic Fonda, New York, is on the New York Central main line in the Mohawk River valley 43 miles west of Albany; trains stopped here until the early 1960's. Note the dates of the structures given on the postcard.

The Fonda, Johnstown and Gloversville Railroad operated 19.7 miles of track between this community and Broadalbin under the banner that hailed the road as the "Sacandaga Route to the Adirondacks." The 1930 *Guide* listed eleven trains daily between Fonda and Gloversville, one on Sunday only, and three daily except Sunday, with only one train (but four buses) daily between Gloversville and Broadalbin. Clearly, the heyday of this route was in the past. In the 1970's, the route was acquired by the Delaware and Otsego Railroad system, a shortline operator with headquarters in Cooperstown, but it was abandoned not long afterwards.

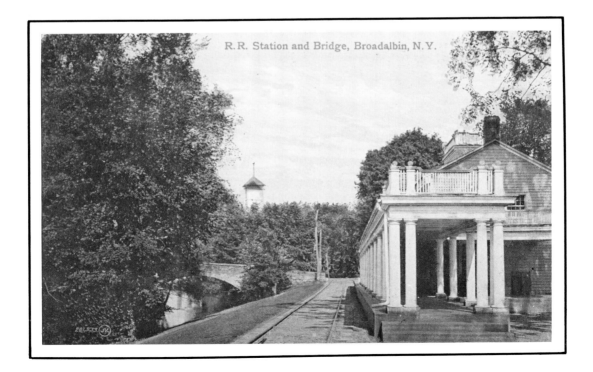

This substantial structure with its Richardson Romanesque design elements at the corner of South Franklin and West Washington Streets in Syracuse was opened by the New York Central Railroad on October 6, 1895. It was the railroad's third station in Syracuse, and it had a large metal train shed attached. As time went on, it was apparent that the tracks through downtown Syracuse would have to go and that the days of useful service of this building as a passenger terminal were numbered. It was officially closed on September 24, 1936, and

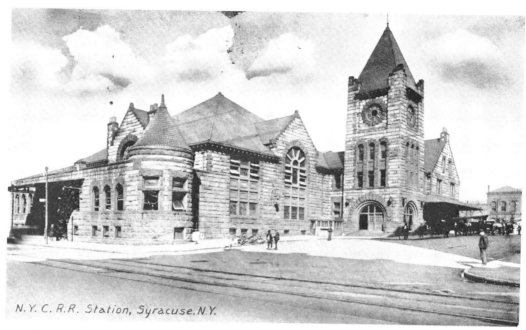

N.Y.C. R.R. Station, Syracuse, N.Y.

a two-day celebration to welcome the new elevated line through the city was carried on by rail officials, employees, and interested citizens. The building stood until demolished in 1939.

The station preceding this one was built in 1870, and the one before that, in 1839. Thus, the first station served for 31 years, the 2nd for 25, the third for 41, and the last one from 1936 to 1962, just 26 years. This is an average of less than 31 years per station, which proves nothing except that in the field of transportation, one can be certain that the fixed constant is change.

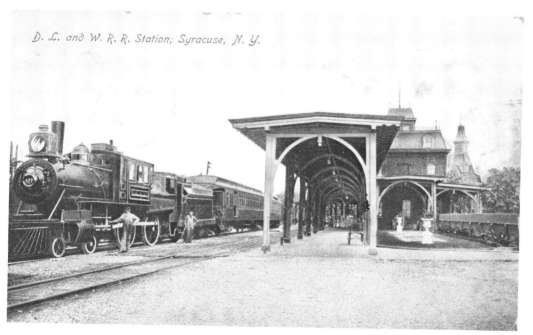

D. L. and W. R. R. Station, Syracuse, N. Y.

This Victorian-style station was built by the Lackawanna Railroad in 1877 and used until 1940 when the tracks were elevated through Syracuse. A new station was built on the same site; it opened on October 21, 1941. For many years, travelers had a choice of accomodations, particularly to New York, and the DL & W offered sleeper and dining car service in competition with the New York Central. To go to the "Big Apple" via the Lackawanna took about 40% more time than travelling the Central, but the "Road of Anthracite"—as the DL & W was promoted—had its adherents.

Service to Oswego was discontinued in 1949, and passenger trains came off the Syracuse-Binghamton line altogether in 1958.

Notice the old armory in the right background, and the massive oil headlight on the "camelback" or "Mother Hubbard" locomotive, with its cab at the center of the boiler rather than behind the firebox.

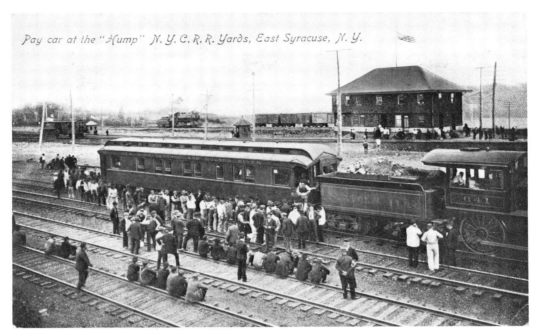

Pay car at the "Hump" N.Y.C.R.R. Yards, East Syracuse, N.Y.

This extremely rare postcard shows a welcome sight to railroad employees; the pay car. In the days when the workers were paid in cash, a pay car like this with armed guards on duty would make the rounds of yards and stations for the paymaster to give employees their earnings. This method of payment persisted until the 1920's. This scene is in the East Syracuse yards of the New York Central; note the yard office in the background.

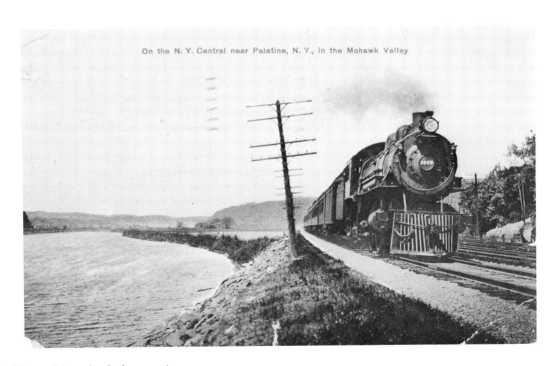

On the N. Y. Central near Palatine, N. Y., in the Mohawk Valley

Of all the mechanical devices conceived by mortal man, probably nothing has attracted more attention from professional and amateur photographers than has the steam engine and all the bits of pieces of railroading that go with it. To those who love beautiful machinery, a steam engine has a heart and soul of its own; it's practically a living thing, and the giant locomotives developed over the years to haul the world's passengers and goods from here to there have held the fancy of such folks like nothing else before or since.

A superb low-profile view like this captures the excitement of standing by the tracks when the monster iron horse thunders by. The existence of literally hundreds of thousands of fine railroad photographs like this taken during the days of steam makes possible the publication of hundreds of books and magazines every year about the roads, their equipment, and their history.

This is the New York Central mainline on the banks of the Mohawk River near Palatine on a section of the road that opened in 1836. The scene dates from 1909 or earlier since the postcard was mailed on October 30 of that year.

7

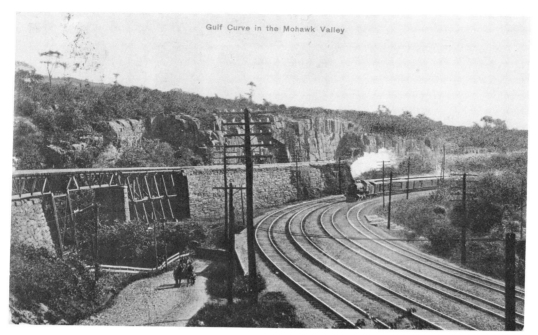

Gulf Curve in the Mohawk Valley

Possibly the worst train wreck to happen in New York State took place here on Gulf Curve, the sharpest on the entire New York Central System's main line, at Little Falls on the Mohawk River. On April 19, 1940 the westbound *Lake Shore Limited* tried to round Gulf Curve at 59 miles per hour instead of the specified 45, and thirty people were killed in the ensuing carnage when the train jumped over two tracks and smashed into the stone embankment just about where the team and wagon are seen in this picture.

The railroad on the embankment is the Little Falls and Dolgeville, which extended 12 miles to Dolgeville and on to Salisbury Center. This was a very difficult road to build; the first three miles of its bed had to be cut from solid rock. The high cost of its construction undoubtedly contributed to the financial downfall of Alfred Dolge a few years after it started operation in 1892. Dolge was a very prominent figure in the piano industry; he located his large factories at Dolgeville because the abundant water supply was ideal for manufacturing felt, and Adirondack spruce was then, as it is today, ideal for construction of sounding boards of which he was the major supplier to the hundreds of piano makers all over America in the late 1800's. In that era, ownership of a piano was a desired mark of social distinction and the building of them constituted a substantial American industry. The card was postmarked in Dolgeville in July, 1909.

The C... of Little Falls in the Mohawk Valley. – On the "New York Central"

This is a westbound view of Gulf Curve long before the terrible wreck on 1940. Elimination of this curve was a tremendous project, and it wasn't until November 19, 1947 that it was finally completed and the newly aligned tracks were open for traffic. The enormous volume of business during World War II and the difficulty of completing the project until the cessation of hostilities undoubtedly contributed to the delay in carrying out the work. In order to re-route the tracks, the Mohawk River had to be diverted.

Note the message on the bottom of the card. Picture postcards came into vogue in the early 1890's, but it wasn't until around 1907 that the Postal Service permitted a message to be written on the back of the card, as is done today. Prior to that time, the writer was obliged to squeeze what he or she could onto a very narrow strip on one of the borders of the picture.

Mohawk Valley below Little Falls, N.Y.

The Dolgeville-Little Falls railroad was conceived by Alfred Dolge as far back as 1882, according to Eleanor Franz' biography of this fascinating industrialist. It finally opened in 1892, but only after frightful cost. Two contractors went bankrupt in the process, and in the end the cost came to $575,000 (an enormous sum for the day) for the 9.96 miles from Little Falls rather than the originally estimated $230,000. Much of this great cost was due to building three miles through solid rock and the necessity of constructing several sizable iron trestles.

But the line had its gala times. On March 16, 1893, a special train with two sleeping cars brought friends of Alfred's eldest son, Rudolf, from New York on the occasion of his wedding to Anita Heller-Schneller; the cars were decorated with banners reading "This is the Dolge-Heller Bridal Party" and "Marriage Is Not a Failure."

The line was eventually absorbed into the New York Central system and was finally abandoned in 1963. In the 1930 *Guide*, the schedule is in narrative form: "Train leaves Little Falls 9:15 am, arriving Salisbury Center 10:10 am. Returning, leaves Salisbury Center 10:20 am, leaves Dolgeville 12:30 pm, arriving Little Falls 1:30 pm." It's probably safe to assume that by the 1930's, operation of the branch was a pretty casual affair.

Alfred Dolge was way ahead of his time in enlightened human relations with his workers. In recognition of his munificence, on December 31, 1881, the townspeople changed the name of the community from "Brockett's Bridge" to "Dolgeville."

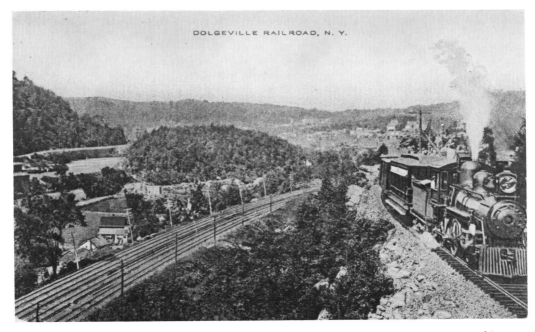

DOLGEVILLE RAILROAD, N.Y.

Here's a 180-degree view from the previous scene, showing a Little Falls & Dolgeville train working up the grade pulling what appears to be an open car commonly used on street railways during the summer. The blast of steam above the engine suggests that the engineer was tooting his whistle at the photographer taking the picture, since no crossing existed at this point to require a signal for safety reasons.

This Brewerton Station scene simply reeks of tranquility in this pastoral setting on a pleasant summer afternoon around the turn of the century. Brewerton is 15 miles north of Syracuse on the St. Lawrence division of the New York Central, a line extending northwards to Watertown (73 miles) and on to Massena (151 miles); passengers were served by it until 1966. Brewerton is a community that was built primarily around boat-building and water-related industry, as it's on the Oneida River just west of Oneida Lake. Fort Brewerton, built in the 1700's, was located here.

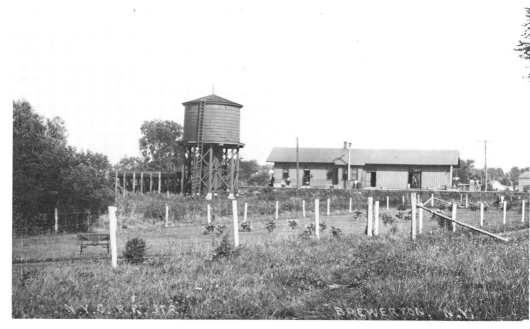

In an era of dieselized railroads, the importance of water in the days of steam is apt to be overlooked. Because steam engines used prodigous amounts of the precious liquid, stops had to be made at frequent intervals to take on a new supply. This meant that most stations of any consequence were equipped with a water tower like the one shown here. Just any old water wouldn't do, either—it frequently had to be treated to minimize foaming and other deleterious effects of improper chemical makeup, and it had to be practically clean enough to drink. Supplying water for the iron horse was always a major problem in arid regions of America and the rest of the world; fortunately for the northeast, ample supplies have always been readily available.

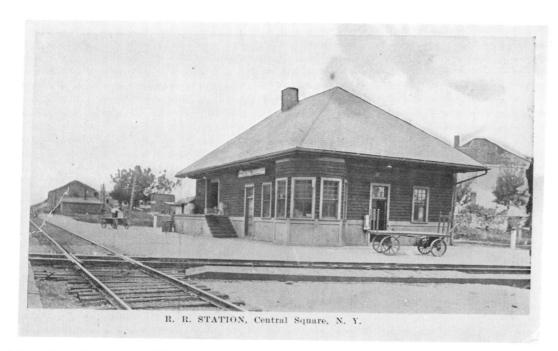

R. R. STATION, Central Square, N. Y.

Central Square, 3 miles north of Brewerton, is where the New York Ontario and Western Railroad's tracks crossed those of the New York Central's St. Lawrence Division—right there in the left foreground of the picture. Note that the station, which still stands in the late years of the 20th century, features a corner bay window, suggesting that the station's architect intended to minimize the difficulties for railroad personnel obligated to keep wary eyes peeled in four directions instead of the usual two.

Numerous creameries and agricultural-related industries were once located here. Typically, creameries were located adjacent to railroad facilities so the milk products from the state's farmers could be rushed to the huge New York City market as quickly as possible.

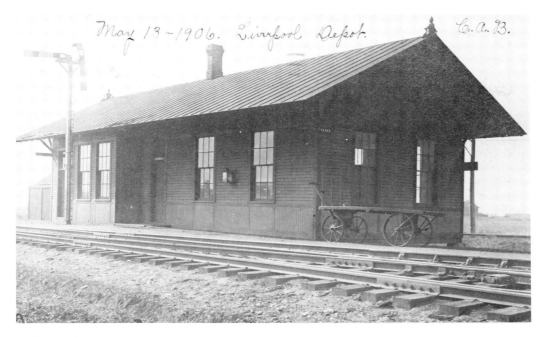

May 13 - 1906. Liverpool Depot. C. A. B.

The Liverpool Station, just 4 ½ miles north of Syracuse, is on the former Rome, Watertown & Ogdensburg Railroad, taken over by the New York Central in 1892. This region of New York State has enormous beds of salt underneath the earth's surface. Over the years numerous extraction businesses have been involved in harvesting this common, but precious commodity. Liverpool is known as the home of a major portion of the salt industry that once lined the shores of Onondaga Lake.

This missive was mailed on May 1, 1906, before the postal service permitted any messages on the address side, and its producer left no space for a message on the front. The owner of this untitled card thoughtfully preserved a bit of history by captioning it and giving us a date for posterity.

One of the most colorful of the many writings on the *Twentieth Century Limited* is the book *20th Century* by the New York society-columnist-turned-railfan author, the late Lucius Beebe. He'd have you believe that a trip on it between New York and Chicago was more in the nature of a social event than a mere train ride, and he's probably right. The top quality of service provided by the New York Central Railroad in terms of speed, comfort, food service, and accommodations naturally attracted a class of affluent patrons for whom the extra fare was well worth the price.

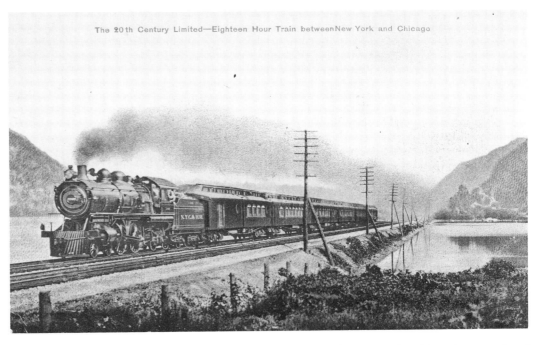

The 20th Century Limited—Eighteen Hour Train between New York and Chicago

Its first run was in 1902, and it served for 65 more years with a fast schedule between the two major cities. A promotional brochure issued when the train was new—about the time this postcard appeared—tells us that the cars were "furnished in specially selected hardwoods, embellished with delicate marquetry. The sleepers contain 12 sections, a drawing room and a stateroom, furnished in vermilion wood and marquetry, with the observation cars' compartments furnished in mahogany, circassian walnut, satinwood and prima vera." Some class!

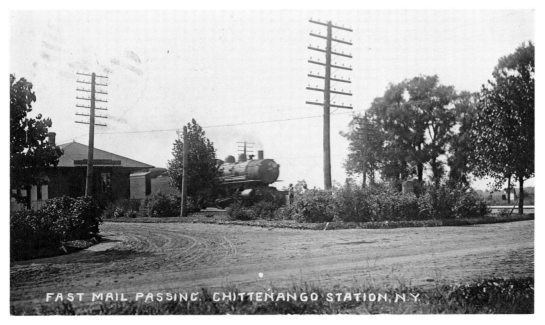

FAST MAIL PASSING. CHITTENANGO STATION, N.Y.

North Chittenango was a stop on the New York Central mainline, 14 miles east of Syracuse. Although the name remains, the station is long gone. Chittenango has at least one basis for world-wide acclaim: it was the home of L. Frank Baum, author of *The Wizard of Oz.*

A great, and alas, long-gone tradition on the railroads is "The Fast Mail." At least in theory, nothing was permitted to delay the swift delivery of the United States mails by the trains, and as a practical matter, the Postal Service was essentially intertwined with and dependent upon America's railroad network to carry out its reponsibilities for fast delivery. Mail was sorted by clerks working in moving mail cars, and they had to be human encyclopedias and gazetteers of the towns and communities along the routes they travelled in order to get the letters and packages into the right sacks and bins for dropping off along the way. Their efforts were closely observed and regulated with demerits being received for mistakes. It was demanding work, but at a time when postal service employment had many advantages, a railway mail clerk's job carried a certain degree of prestige. It may be that today's first class mail carried by jet aircraft gets to us faster, but it doesn't always seem that way.

As always, history tends to repeat itself; in the mid 1980's, Amtrak trains were again hauling bulk mail in special cars coupled between the locomotive and the passenger equipment.

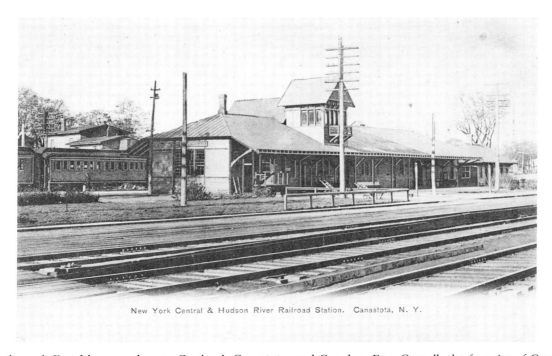

New York Central & Hudson River Railroad Station. Canastota, N. Y.

This station was built by the West Shore Railroad during its construction in the 1880's, and it was used jointly by the New York Central mainline. Through this area, the West Shore was electrified in 1907 and operated as a third-rail interurban between Utica and Syracuse, a distance of 49 miles, until December 31, 1930.

Canastota was also served by the Elmira and Cortland branch of the Lehigh Valley Railroad, the old Elmira, Cortland, and Northern Railway which had been absorbed by the Lehigh. This branch extended from Elmira northeasterly through East Ithaca, and on to Cortland, Canastota, and Camden. Ezra Cornell, the founder of Cornell University, invested heavily and lost heavily in the Ithaca and Cortland Railway, incorporated in 1869. At one time this rail line had a station on the Cornell Campus.

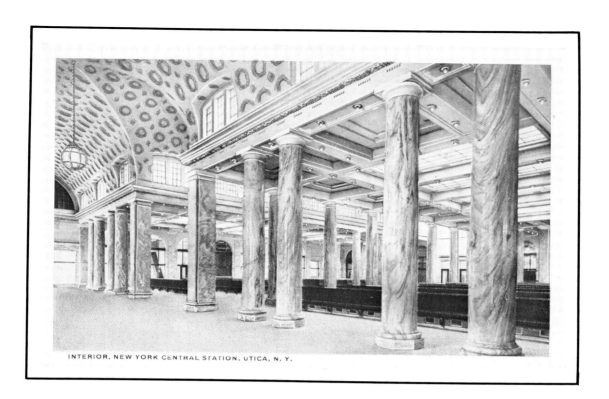

INTERIOR, NEW YORK CENTRAL STATION, UTICA, N. Y.

Construction of the New York Central's magnificent passenger station in Utica began in 1912. It was completed in May of 1914 at a cost of around $1 million. Its architects were some of the men who designed New York City's Grand Central Terminal—among them were Allen H. Stem and Alfred Fellheimer who rendered one of the finest stations in upstate New York in the grand manner with massive marble columns in Renaissance Revival style. It is said that many of the columns came from the original Grand Central Terminal in New York City. Note the enormous clock above the colonnade facing the street. The building became a "Union" station in 1915 when the Delaware, Lackawanna and Western and the New York, Ontario and Western Railroads abandoned their station west of Bagg's Square and moved in with the Central.

Here travelers waited for and boarded trains for the Adirondacks and Watertown while management and office employees of the Mohawk Division carried out their duties in other parts of the building. Today, in the late years of the 20th century, the building still serves the public in a variety of ways. *[Details from an article by Douglas Preston, Director of the Oneida County Historical Society, writing for the Utica Observer-Dispatch in 1986.]*

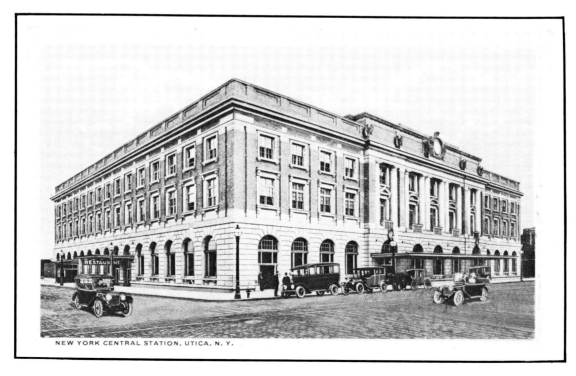

NEW YORK CENTRAL STATION, UTICA, N. Y.

13

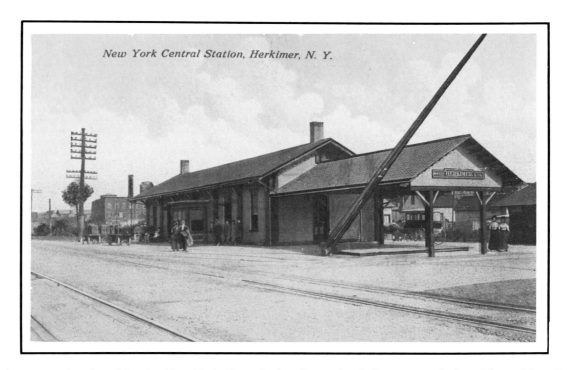

New York Central Station, Herkimer, N. Y.

The station above was abandoned by the New York Central when its modernistic new one designed by architect J. P. Gallagher was opened on April 5, 1943. It was an occasion for celebration, and practically the whole town—including school children who took time off from their studies—joined in the festivities.

It marked the completion of an enormous relocation project that moved the passenger tracks away from the main business streets, efforts having been made to initiate such an job as early as 1903. Legislation was passed in Albany in 1938 that provided for the state to pick up most of the $3,500,000 cost with the Central paying up to 15% of the cost of certain portions of the project when the railroad benefited from them.

Readers who enjoy statistics and trivia will be pleased to know that 14 miles of track and three bridges were involved, and that the relocated line is 3 1/2 miles long—513 feet shorter than the line it replaced. The bridge over Mohawk Street is on a skew of 38 deg. 40 min., and the lengths of its girders between bearings ranges from 86 ft. 6 in. to 92 ft. 6 in. The bridge across West Canada Creek is 598 feet with six 75-foot spans and two 74-foot spans. Nine hundred thousand cubic yards of grading was required; the Lane Construction Company of Meriden, Connecticut did this work, street work, and bridge substructures under the supervision of J. W. Pfau, chief engineer of the New York Central, Lines Buffalo and East. The new station has overall dimensions of 49 ft 6 in by 78 ft 8 in, and the Mutual Construction Company of New York built it. Its passenger platform, 1200 feet long, featured a steel butterfly canopy 300 feet long. The American Bridge Company erected the bridges.

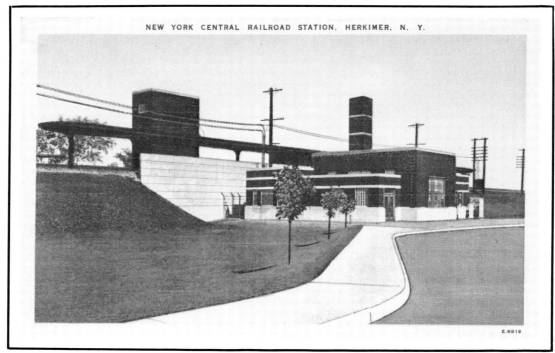

NEW YORK CENTRAL RAILROAD STATION, HERKIMER, N. Y.

E-8919

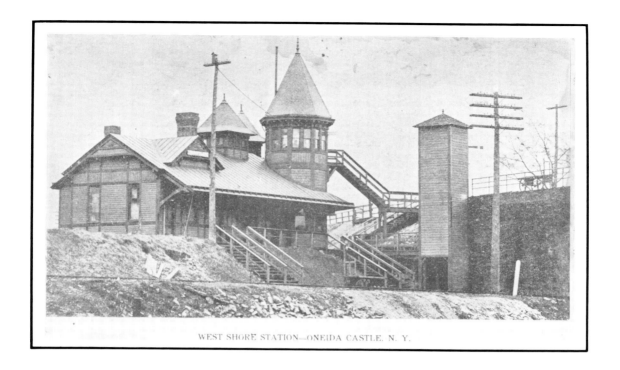

WEST SHORE STATION—ONEIDA CASTLE, N. Y.

At Oneida Castle, passengers going to Sylvan Beach ten miles to the north on Oneida Lake would detrain from the West Shore "Third Rail" on the upper level, and then walk or take the elevator to the Ontario and Western, below. The Sylvan Beach trains originated from this unusual "split level" Queen Anne-style station. The electrified line is seen in the lower postcard. It is known as a "third rail" operation since the electricity required to drive the heavy interurban cars is picked up from a third track instead of from an overhead wire system commonly associated with trolley cars. In fact, this technical terminology came into general use by the traveling public using this line, as indicated by the message on the card written to Clarence E. Ottaway in Hartwick, New York, on August 29, 1910:

"Dear Brother: We arrived home safely at 10:30. The third rail cars were fifteen minutes late out of Utica. Mary."

In his fascinating book *O & W—The Long Life and Slow Death of the New York Ontario and Western Railway* William Helmer writes that the station was built by Josiah Jenkins of Vernon for $8,000 with the West Shore paying ⅔ and the O & W, ⅓. History buffs wishing to read a long sad story, humorously written, are encouraged to peruse its pages.

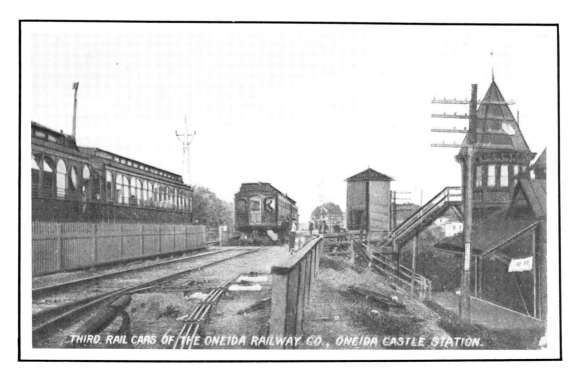

THIRD RAIL CARS OF THE ONEIDA RAILWAY CO., ONEIDA CASTLE STATION.

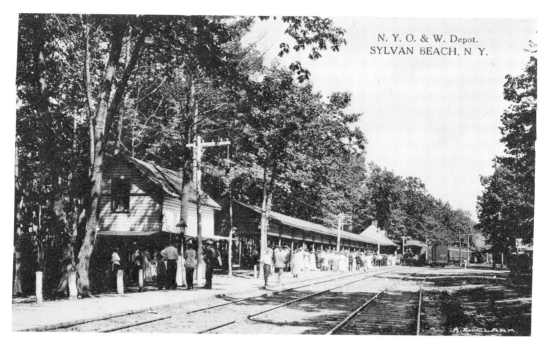

N. Y. O. & W. Depot.
SYLVAN BEACH, N. Y.

Sylvan Beach has been a popular summer resort since the 1880's. This O & W station was built in 1892 and still stands at this writing, although the adjacent shed has long since been removed. An amusement park was located here, and small steamboats provided transportation on the lake. The Lehigh Valley Railroad also operated trains to Sylvan Beach over its branch extending to Camden.

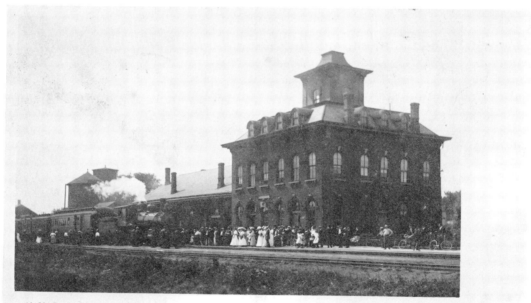

N. Y. O. & Western Depot, Oneida, N. Y.

Photo by Wiggins

The imposing Oneida Station of the O & W on Sconondoa Street also housed the railroad's division offices. Erected in 1870, it served for 69 years and was razed in 1939. Passenger service north of Oneida to Oswego had been discontinued in 1931.

The O & W history dates to the mid-1860's, and it ends on March 29, 1957. It was the largest Class 1 railroad in the United States ever to be essentially abandoned in its entirety—all 544 miles. It had its moments of glory, but the basic underlying problem plaguing it for all its years was that it simply didn't go any place where much revenue could be produced. Small towns with little industry on a line stretching through mountains and farm country from New York to Oswego simply couldn't provide it.

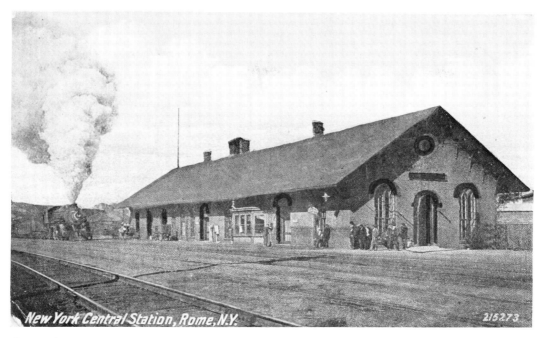

New York Central Station, Rome, N.Y.

Rome was the southern or eastern terminus of the Rome, Watertown, and Ogdensburg Railroad, formed in 1861 from the Potsdam and Watertown Railroad (which began operations in 1857) and the Watertown and Rome (which was chartered in 1832, but which didn't get rolling stock moving until 1851). Its 643 route miles came under control of the New York Central & Hudson River Railroad on March 14, 1891. This station still stands at this writing, although it has long ceased to be a railroad building.

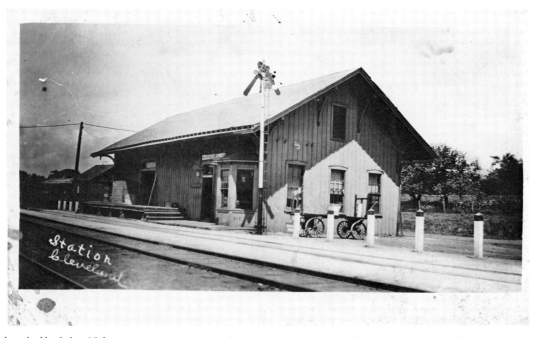

Station Cleveland

During the last half of the 19th century, numerous glass works were located in the vicinity of Cleveland, on the north shore of Oneida Lake. For the most part, however, the line north from Oneida to Oswego generated very little business beyond excursion trains and, in earlier days, hop pickers' specials. The largest number of customers were in Fulton and Oswego, which were apt to be better served by other railroads. The cultivation of hops, the basic ingredient for brewing beer, was a substantial factor in New York State agriculture for many years until wiped out by disease in the early part of the 20th century.

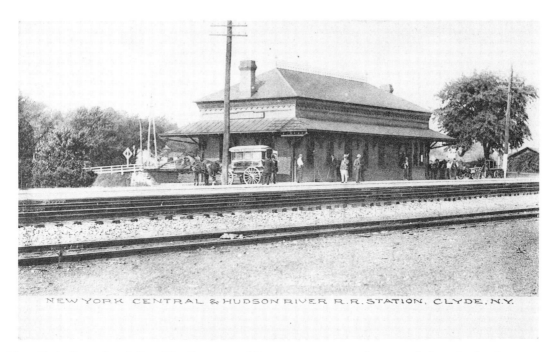

NEW YORK CENTRAL & HUDSON RIVER R.R. STATION, CLYDE, N.Y.

Clyde, on the New York Central mainline 38 miles west of Syracuse, was one of a several stops for local passenger trains between Syracuse and Rochester. This station, built in the 1880s, was demolished in 1969. Many years previously it was the site of a glass factory. Note the horse-drawn "depot hack" very likely owned by a local hostelry eager to pick up business from piano travelers, whiskey drummers, or other traveling salesmen who were an important part of the passenger traffic of the railroads of that era.

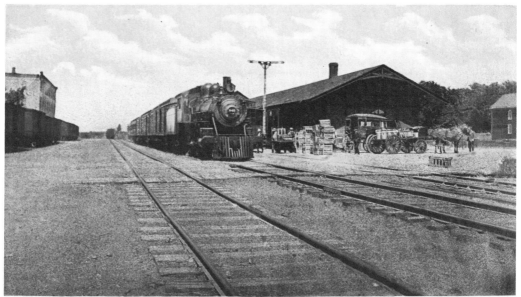

Railroad Depot, Wolcott, N. Y.

Located in the heart of the fruit belt of central New York, Wolcott was an important stop on the Ontario Division of the New York Central. This was, and is, a rich agricultural district for apples, peaches, pears, general produce, and poultry. Wolcott is now on the Ontario Midland, a shortline railroad. It was created when Conrail, the quasi-public rail enterprise created by Federal legislation in the 1970's to save the remains of Penn Central and other railroads in the Northeast, planned to abandon its tracks.

The line from Rochester to Oswego was 79 miles long with 24 towns between. In 1930, two local trains each day made the trip, stopping at each station, and taking some 3 ½ hours to travel the total distance—an average speed of about 22 miles per hour. Note the horse-drawn wagon with its load of milk cans and the large pile of crates ready to be loaded onto the baggage or, perhaps, the Railway Express car.

18

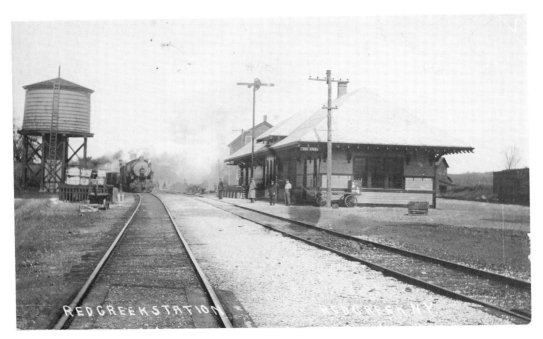

Red Creek was the next stop east of Wolcott on the Ontario Division of the New York Central; now, it is the eastern terminus of the Ontario Midland. This part of the Central system was often referred to as the "Hojack Line"; regretfully the origins of this interesting term appear to have been lost in the mists of antiquity. This card was mailed in 1914.

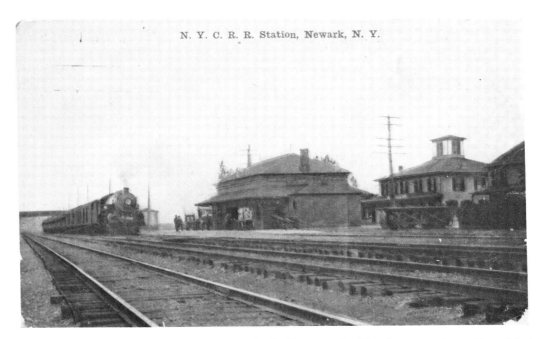

N. Y. C. R. R. Station, Newark, N. Y.

Newark's New York Central station was built in the 1880's; looking east in this picture are two adjacent hotels. This card was postmarked in 1912. For many years, rose fanciers from all over the United States came to see the famous Jackson Perkins rose gardens. The firm is now located in the state of Oregon, but the rose gardens remain.

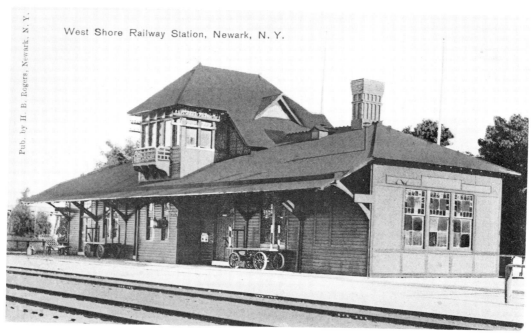

West Shore Railway Station, Newark, N. Y.

Typical of the Queen Anne style of architecture favored by the West Shore railroad was its station in Newark. At this point the West Shore was almost a mile south of the New York Central main line but was much more convenient for passengers. Passenger service ceased to exist on the West Shore in 1934.

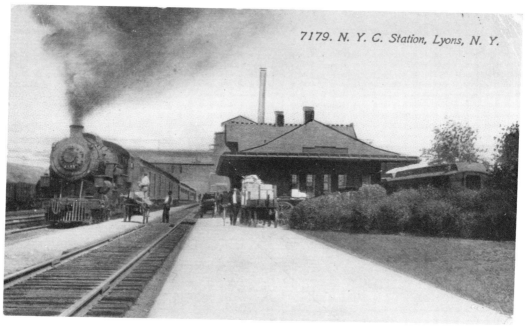

7179. N. Y. C. Station, Lyons, N. Y.

Lyons is the seat of government for Wayne County; at one time it was an important junction point between the New York Central mainline and its Pennsylvania Division, also known as the "Fall Brook," which ran south to Corning and on into the Keystone state. Extensive shops and coaling facilities were once located here. This brick station, with a large and comfortable waiting room, was erected in 1890. Prior to the time of this photo, there were covered platforms along the tracks to provide a modicum of protection from the elements for boarding and alighting passengers. One of the first experiments in the production of sugar beets in New York State occured at Lyons in the early 1900's.

Most of the mainline passenger stations in these small communities were gone by the mid 1960's.

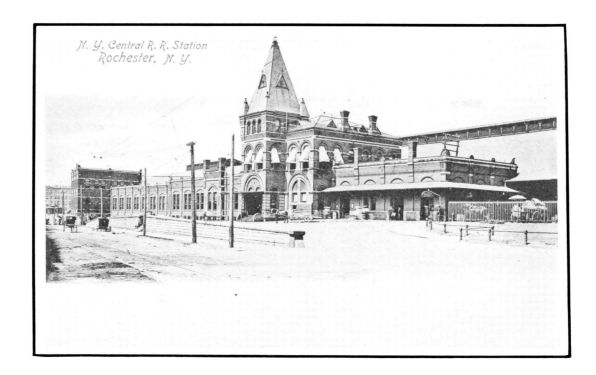

N. Y. Central R. R. Station
Rochester, N. Y.

The New York Central erected this elaborate Victorian station in Rochester in 1886 and used it for the next 30 years. It was located on Central Avenue and St. Paul Street, and it featured an enormous trainshed on its far side as seen in the card below. General division offices were located in the two story square building next to the street. In the glory days of railroading, well over a hundred train movements a day took place in and out of this station, thanks to Central's tracks radiating in five directions: to Buffalo in the west, Niagara Falls to the west, Charlotte to the north, Canandaigua to the south, and Syracuse to the east. Note that three of the four passenger cars in the scene have open platforms; only one has an enclosed vestibule. This was a period of transition in the architecture of car design and construction. The card showing the trainshed was postmarked in 1905.

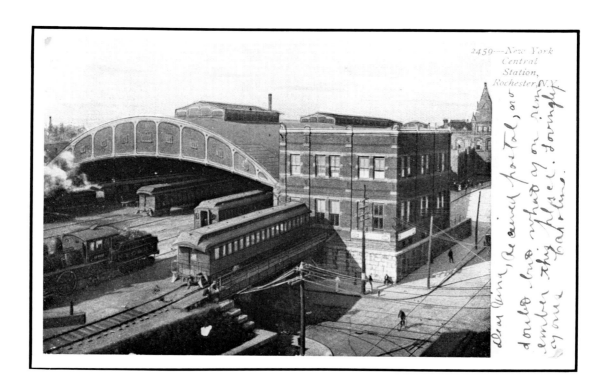

2459—New York Central Station, Rochester, N.Y.

21

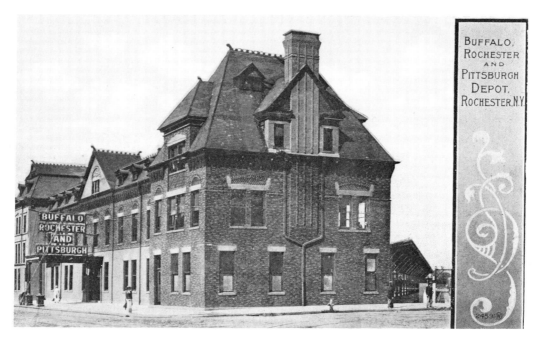

The Buffalo, Rochester & Pittsburgh Railroad in 1930 had 602 miles of track serving the three cities in its name. The lines from Buffalo and Rochester extended southward and joined at Ashford, 15 miles north of Salamanca, where the track continued on to Pittsburgh and other points in Pennsylvania. The system was eventually absorbed into the Baltimore and Ohio Railroad. Rochester's Gothic-style station on West Main Street still stands; it was built in 1881 and is one of the city's landmarks. Passenger service to Salamanca lasted until August 29, 1953, and for years the railroad offered its patrons some nice amenities with Observation Parlor Car, Dining Service, and 12-section Drawing-Room Pullmans on through trains.

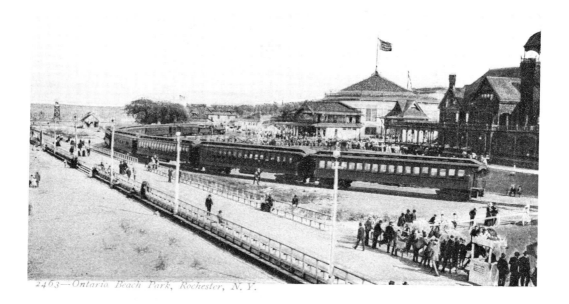

One of the many amusement parks served by the New York Central was Ontario Beach Park at Charlotte, 9 miles more or less north of Rochester as measured by the length of track between the stations. Before Henry Ford's idea of mass marketing automobiles to the common man caught on, the iron horse was a significant means of transportation to many parks like this across America.

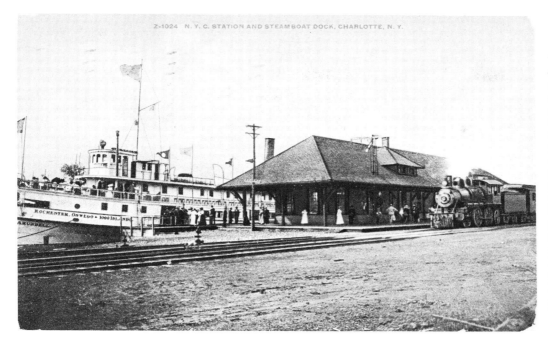

Charlotte (pronounced "Sha-lott" by the locals), on Lake Ontario just north of Rochester, was one of the busiest points on the New York Central's "Hojack" or Ontario Division during the early 1900's. Here, excursionists de-trained and went aboard steamboats to various points along Lake Ontario. Regularly scheduled steamboat service existed between Charlotte and the St. Lawrence River until about World War I. The New York Central also operated commuter trains between Charlotte and downtown Rochester.

The "Arundell" was built in 1878 by the David Bell Steam Engine Works in Buffalo. The Union Dry Dock Company in Buffalo lengthened the craft, of 23 foot 9-inch beam, to 179 feet in 1890. The vessel carried both passengers and freight and was used on Lake Ontario out of Oswego in the 1897-1908 era. It was owned by the Crawford Transportation Company and burned in 1911 at Douglass, Michigan.

The craft was named for Thomas Arundel, Archbishop of Canterbury in 1396, although it's not clear why the owners spelled the name with two l's.

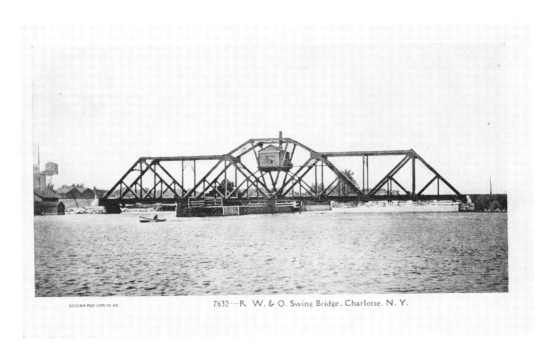

SOUVENIR POST CARD CO. N.Y. 7632—R. W. & O. Swing Bridge. Charlotte. N. Y.

To allow ships to pass up the Genesee River, the Rome, Watertown & Ogdensburg (which became part of the New York Central) erected this swing bridge across the waterway at Charlotte. Note the operator's control shanty suspended from the center of the span. At the time of this writing, it is used to provide part of the coal route to the Beebe steam plant in downtown Rochester, and to store cars on the east side of the Genesee River at Charlotte. The bridge remains open for water traffic from April 1 to December 15 during which time it is operated to accomodate the rail needs. The balance of the year it is aligned for rail use except when needed for any late and infrequent commercial water traffic.

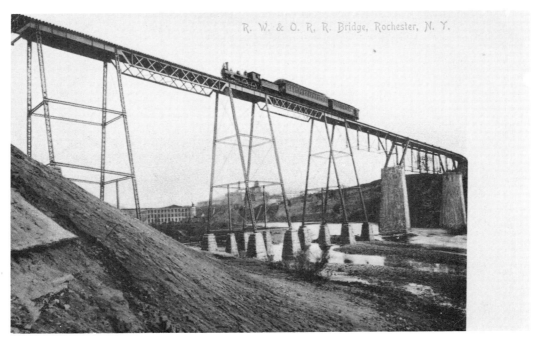

The Rome, Watertown, and Ogdensburg Railroad built this spindly bridge across the Genesee River to gain access to the city of Rochester. Its design might be termed somewhat eclectic, with both stone and steel supports, deck beams supporting the track at the top of the steel, two designs of inverted steel truss, and one upright truss with the track on its top.

The Rochester and Eastern Railway, an electric interurban line connecting Rochester with Geneva by way of Pittsford, Victor, Canandaigua, and Seneca Castle (a distance of 44 ½ miles), was built during 1902 and 1904. In his book *The Route of the Orange Limited* William Gordon says: "In 1904 a famous event occured which covered the Rochester and Eastern with much glory. For a considerable distance, the electric line paralleled the Auburn Branch of the New York Central and Hudson River Railroad. Many people had wondered which was the

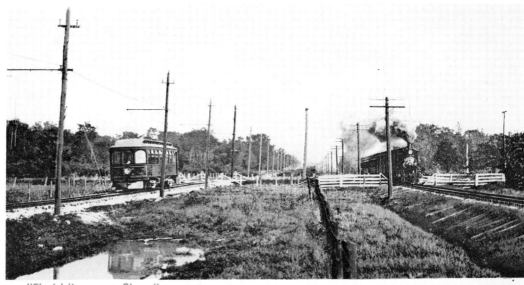

"Electricity versus Steam".

Showing the tracks of the Rochester and Eastern Rapid Railroad and the Auburn branch of the New York Central and Hudson River Railroad where they parallel each other between Rochester and Canandaigua, with the trains of each road running at full speed in the same direction. The electric car here shown is capable of making a speed of sixty miles an hour.

faster means of travel. Therefore, a race was staged between a 4-car passenger train on the Central, and an interurban on the Rochester and Eastern. Electricity proved the faster means of travel on that memorable day." And, we might add, plenty of postcards like this one produced in Leipzig, Germany, were put into circulation thus providing a vast amount of free promotional advertising for the company.

While this was surely an interesting spectacle, the network of interurban electric railways covering much of central upstate New York in the early years of the 20th century was doomed from the start. It's an axiom in the transportation business that except for highly special situations, the only way a privately-owned company can make money and stay in business is to haul heavy loads long distances. The inter-city trolley lines did just the opposite—they were built mainly to carry passengers short distances. The advent of the private automobile merely hastened the end of the concept.

24

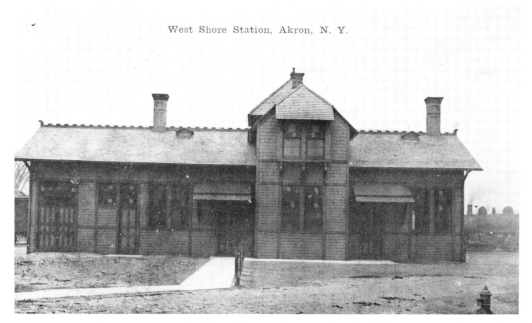

West Shore Station, Akron, N. Y.

Some of the fanciest stations in the upstate area were built by the New York, West Shore, and Buffalo Railway which was completed across New York State in 1883 as a competitor to the New York Central. The station at Akron, a few miles east of Buffalo, was typical of the "Queen Anne" style of architecture prevalent at the time. Virtually all of the West Shore stations were built in the same ornate design, right down to the stained glass windows. Akron was also a station on the New York Central's so-called "Peanut" branch running from Canandaigua to Tonawanda. By 1886, the West Shore was taken over by the New York Central and ceased to exist as a separate entity.

Lockport's ornate station on the "Falls Road" of the New York Central served for more than 60 years. The New York State Railroad Commissioner's Report for 1890 noted that, "The new passenger station at Lockport is an imposing structure of stone and brick. It has a covered carriage-way entrance into the rear, beautifully carved, an arched entrance into a vestibule at front, and all the modern improvements inside. As a whole it is, as before stated, unique." Passenger service on this 77-mile line running from Rochester to Niagara Falls was discontinued in 1957.

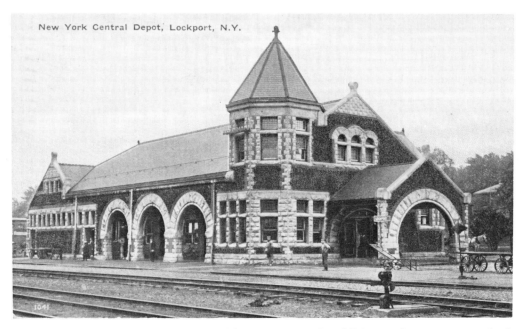

New York Central Depot, Lockport, N.Y.

In those days, as now, the post office was sticky about getting paid for its services. In addition to the message on the back of this card are two rubber-stamped notices: one says "HELD FOR POSTAGE" and the other says, "This is the mail for which you sent postage." Evidently, the recipient of the card, a Miss Emily Willard of Seneca Falls, was obliged to forward the sum of a penny to the postmaster in Lockport after receiving notice from him of a shortage, whereupon he affixed a one-cent stamp, postmarked the card on August 4, 1913, and sent it on its way. The message is:

"My dear Emily -- was very glad to get your letter & know that you can come next Sat. Hope you will be in time for the family picnic. Can't you come Friday instead as to get rested up before the picnic & bring Julia too if your mother is willing. We would love to have you both. Lovingly yours, Bessie."

Alas, we will never know if the delay occasioned by the failure to affix a one-cent stamp spoiled this otherwise well-attended family affair.

Possibly the most famous train in all North America, if not the world, was the New York Central's *20th Century Limited,* operating between New York City and Chicago. Service was inaugurated in 1902 on a 20-hour schedule. By 1925, it required eighty-seven sleeping cars, twelve club cars, eight diners, twenty-four locomotives, and a handful of observation cars to operate the service. This view of the train racing along the shores of Lake Erie prior to 1920 was duplicated in vast quantities as a promotional piece.

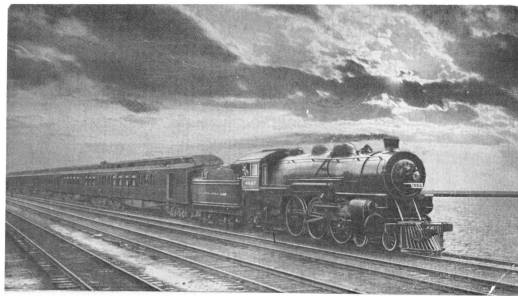

TWENTIETH CENTURY LIMITED, VIA NEW YORK CENTRAL LINES
Finest and fastest long-distance train in the world

In his delightful book *20th Century* Lucius Beebe, the great chronicler of American railroading, obviously enjoys relating in great detail how the train catered to the high and mighty and socially prominent. He tells of one westward trip wherein he encountered "such an assortment of names that made news as Lionel Barrymore, Louis Wiley, the business manager of *The New York Times*; Gene Tunney, the Countess Dorothy de Frasso, sports writer Grantland Rice, the ranking art critic of the time, the bearded and courtly Royal Cortissoz; ex-President Herbert Hoover, Henry Sell, editor of *Town and Country*; Rufus Dawes, the Chicago banker; and the inevitable seismographic disturbance provided by the joint presence of Ben Hecht and Charlie MacArthur who had written a play about the train and were double-starred celebrities with the train crew." The latter reference alludes to the famed Broadway play *20th Century* based on the train and the life aboard it.

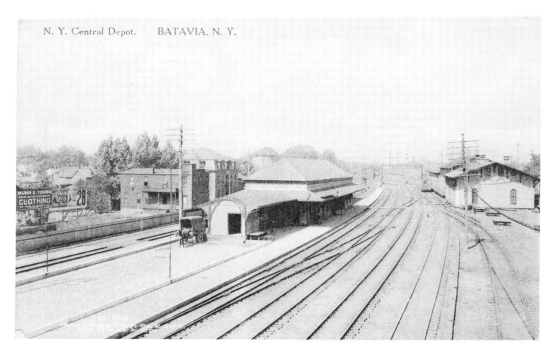

N. Y. Central Depot. BATAVIA, N. Y.

There's not a car to be seen in this early view of Batavia. As happened with so many other communities, the railroad was built through the center of town . . . or more likely, the "center of town" grew around the railroad. In a few short years placid scenes like this one gave way to masses of automobiles and the resulting small-town version of urban gridlock. Batavia was no exception to this common occurrence. Early in 1957, a massive relocation project was completed that eliminated eighteen grade crossings and provided a new station at a total cost of $12,118,000. Note the horse-drawn wagon.

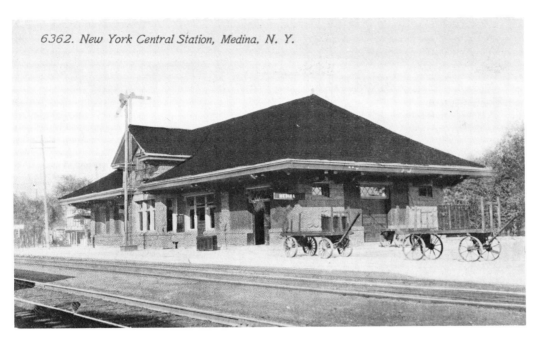

6362. New York Central Station, Medina, N. Y.

Medina, 41 miles west of Rochester on the New York Central's Falls Road, boasted this typical station of the pre-World War I era when passenger service was in its prime. It was built of native Medina Sandstone and brick. Passenger service was discontinued on this line in 1957.

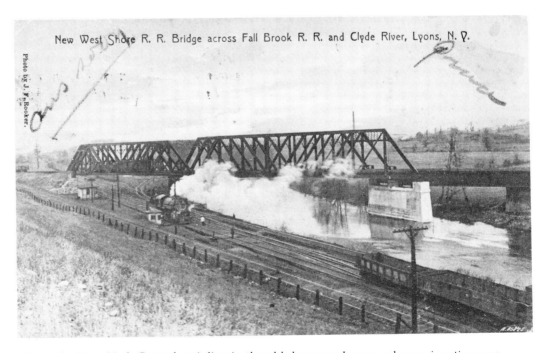

New West Shore R. R. Bridge across Fall Brook R. R. and Clyde River, Lyons, N. Y.

Photo by J. F. Rooker.

One of the more interesting points on the New York Central mainline in the old days was Lyons, where a junction was made with the Fall Brook (south to Geneva and Corning), and the West Shore. The Central maintained coaling facilities here as well as a large enginehouse. Nearby was one the first sugar beet processing plants in the United States. In this scene, the West Shore crosses the Clyde River.

This card was published by W. E. Bourne of Lyons as Number 11 of a series, and it was printed in Germany as were many cards prior to World War I. Dyed-in-the-wool postcard collectors often enjoy trying to collect an entire series put out by a particular publisher. This may have been one of a series of railroad shots or simply of general scenes around the community.

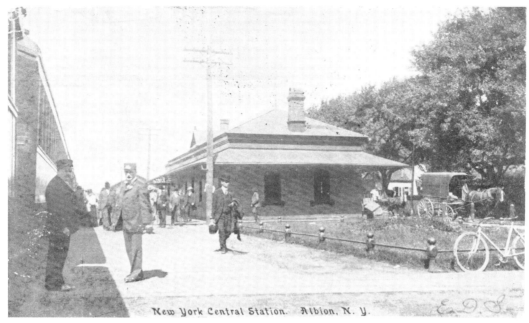

New York Central Station. Albion, N. Y.

The conductor and the trainman seem to be a bit suspicious of the motives of the chap who took this picture while a derby-ed dandy well-outfitted with raincoat, valise, and high celluloid collar strolls by. Note the horse and wagon at the right.

Albion, the county seat for Orleans County, is on the former New York Central "Falls Road," a shortcut for through freight and passenger trains between Niagara Falls and Rochester, bypassing Buffalo. It had been an important "port" on the Erie Canal, with several mills and agricultural implement factories. Passenger service on this line was discontinued in 1957; at this writing, the line is no longer used as a through route.

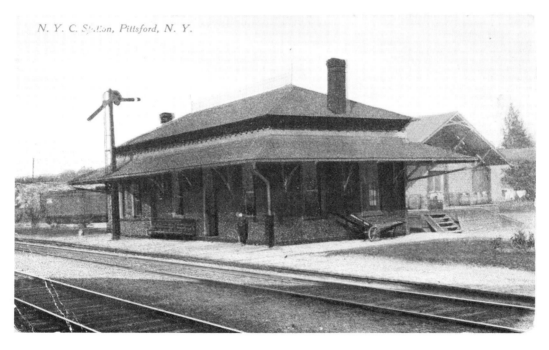

N. Y. C. Station, Pittsford, N. Y.

The station at Pittsford, on the New York Central's Auburn Branch, was typical of those built of brick at various points of the railroad in the 1880's. Compare this picture with the those of the stations at Albion and Clyde; the structures appear to have been built from the same set of blueprints. In 1989 the freighthouse and station house the Depot Restaurant; the tracks have been abandoned at this point for many years.

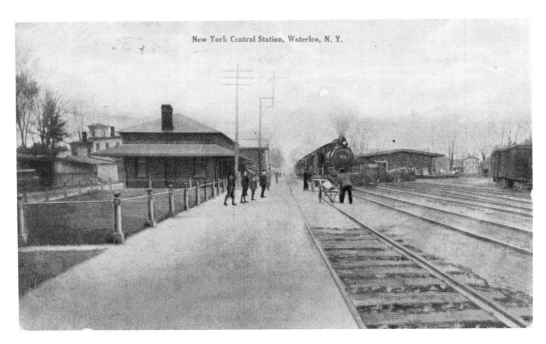

New York Central Station, Waterloo, N. Y.

Waterloo, the seat of government for Seneca County, was on the New York Central's Auburn Branch, and its railroad station followed the "standardized" pattern of those built by that line in the 1880's. It stood until the 1960's.

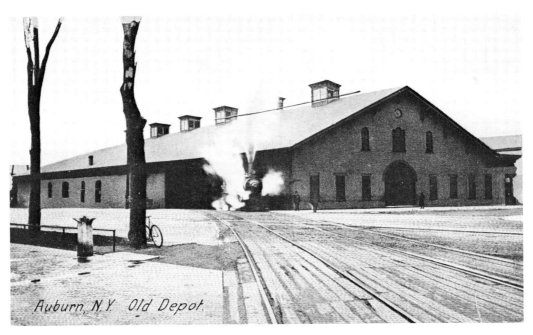

Auburn, N.Y. Old Depot.

In the early days of railroading, it was common to build a completely sheltered station where the trains would come right inside, out of the weather, instead of the designs of later years featuring long protective canopies along the outside tracks. One such "through" station was the New York Central depot in Auburn, constructed in 1842 as a joint depot of the Auburn & Rochester, and Auburn & Syracuse Railroads, which eventually merged. This station, adjacent to the Auburn State Prison, was replaced in 1906.

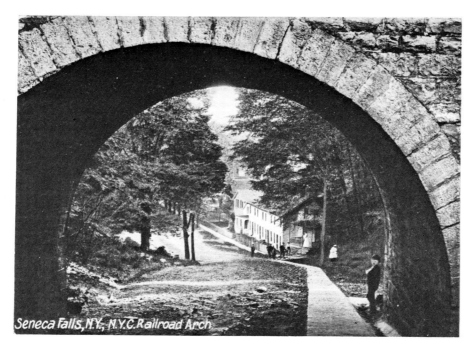

Seneca Falls, N.Y., N.Y.C. Railroad Arch

Before being flooded during the construction of the New York State Barge Canal, the lower part of Seneca Falls was a residential and industrial area. Today, this portion of the town, seen here through the stone arch supporting the New York Central tracks, is under water.

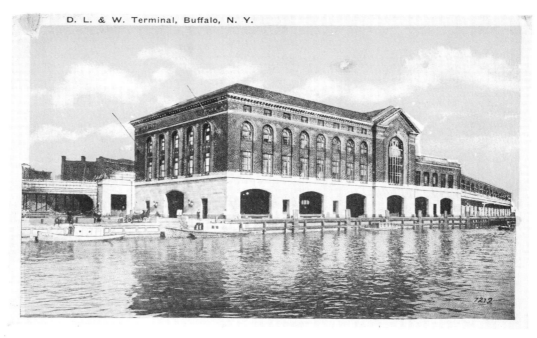

D. L. & W. Terminal, Buffalo, N. Y.

The Lackawanna Railroad terminal at the foot of Main Street in Buffalo was opened for business on February 7, 1917. It was also used by the Nickel Plate, Baltimore and Ohio, and Wabash Railroads. The Erie-Lackawanna closed it in February 1962 but continued to run one train a day, *The Owl*, No. 15, to Buffalo until May 23, 1969—although it operated out of Babcock Street. This station was demolished in the late 1970's, but the tracks and train sheds continue to serve the city's new subway system.
Because this card was postmarked in 1917, the building looks new, bright, and shiny.

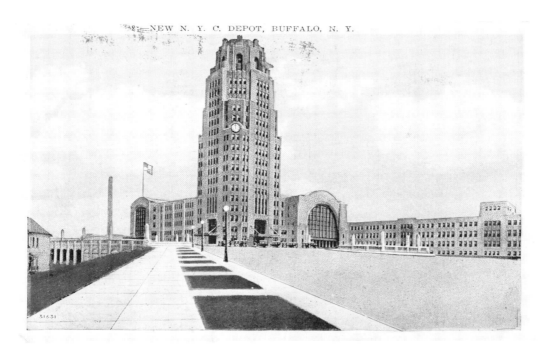

Central Terminal, grandest of the railroad stations in western New York, opened with appropriate ceremonies on June 22, 1929. It replaced the Exchange Street Station, which was razed on November 13, 1935. Central Terminal also served the Pennsylvania Railroad. It was used until 1978 when a much smaller building—referred to by detractors as an "Amshack"—was erected by Amtrak in nearby Depew. A smaller Exchange Street Station, opened in 1952 and used for only a few years, was re-opened in the late 1970's when passenger service was re-established to Niagara Falls.

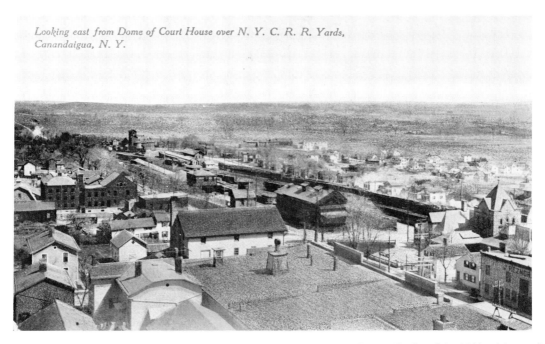

Looking east from Dome of Court House over N. Y. C. R. R. Yards, Canandaigua, N. Y.

Canandaigua has had rail service since the completion of the Auburn & Rochester Railroad in 1841 with much of the financing coming from this community. In 1851, just ten years later, the Canandaigua & Corning Railroad between Canandaigua and Watkins Glen was completed. It originally was a six-foot gauge line; eventually it was extended to Niagara Falls. The portion between Canandaigua and the Falls was sold to the New York Central and changed to standard gauge (four feet, eight-and- one-half inches) in 1857. The eastern portion eventually became a Pennsylvania Railroad property. Both roads had extensive yards here to serve local industries; today, a single track of the Auburn branch ends here, served occasionally by Conrail.

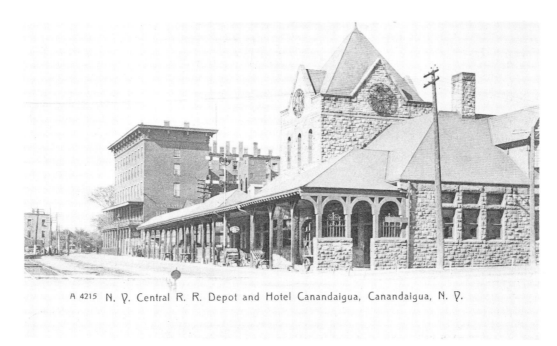

A 4215 N. Y. Central R. R. Depot and Hotel Canandaigua, Canandaigua, N. Y.

This elaborate station built of cut stone, which still stands and serves as an office building, was erected by the New York Central in Canandaigua in 1890. Prior to this, the hotel in the distance served as a station and waiting room. Until 1955 the Pennsylvania Railroad provided sleeping car service to Canandaigua, connecting with the New York Central, which took the cars on to Rochester. Passenger service on the Auburn branch from Syracuse to Rochester via Canandaigua was discontinued on May 19, 1958. Since then, the Auburn branch has been abandoned between Canandaigua and Rochester.

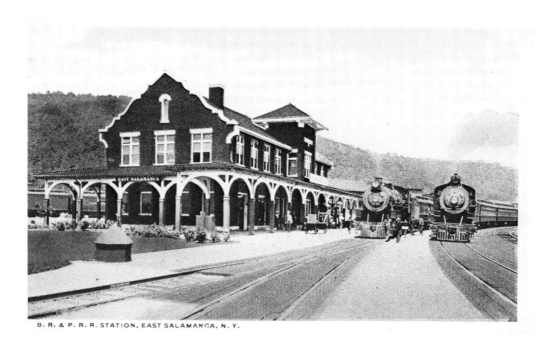

B. R. & P. R. R. STATION, EAST SALAMANCA, N. Y.

East Salamanca's fine brick station was built by the Buffalo, Rochester, & Pittsburgh in the early 1900's, and has been restored as a museum to acquaint today's generation with fascinating details of railroading in years past. Passengers could make connections here with the Erie Railroad, which runs east and west through the community.

Much of the community of Salamanca, re-named from "Great Valley," is on the Seneca Indian Reservation, though East Salamanca where this station is located is outside of the reservation boundary. The name comes from the Spanish Marquis of Salamanca who was involved in the financing of the Erie Railroad through here immediately prior to the Civil War. The Marquis made his money in the construction of new railroads in Spain, France, and Italy.

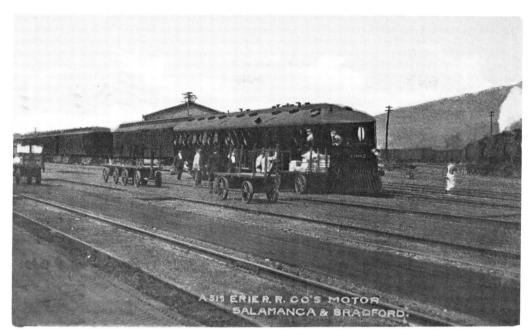

The McKeen Motor Car Company of Omaha, Nebraska, built 152 of these internal-combustion-powered railcars between 1905 and 1917, and sold them to railroads for branch line work where passenger traffic was light, of which the Salamanca and Bradford branch of the Erie was typical. Rigs of this nature were popular with railroad managements because they were much less costly to operate than were steam trains of the same carrying capacity. Factory records, as revealed by Edmund Keilty in his fascinating book *Interurbans Without Wires* tell us that this car was built in August 1909, weighed 32 tons, was 74 feet long, seated 64 passengers, and was powered by a 200- horsepower gasoline engine. The Erie bought three such cars from McKeen.

They were popularly known as "Windsplitters" because of their sharp nose, although their speed was not so fast that wind resistance made much difference. Most McKeen cars had round passenger windows like those on Erie's #1002.

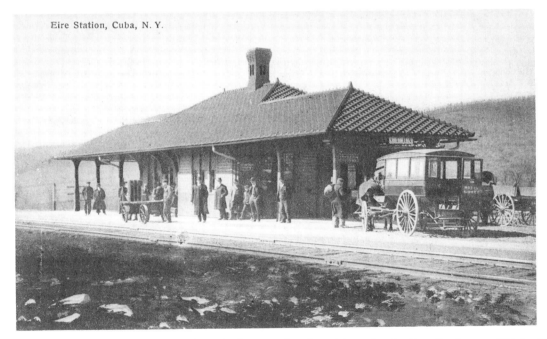

Cuba, 33 miles east of Salamanca on the Erie's main line, made a lot of fame for itself as the home of Cuba Cheese. Back around the turn of the century, the market for cheddar cheese in Cuba actually established the price throughout the United States. At one time, it was also the junction point of an elaborate system of narrow gauge railroads. The wagon poised at the edge of the track is of a typical design seen even today where Amtrak serves the public. It has a high bed that is level with the floor of the baggage cars of the trains to ease the in-and-out movement of checked luggage, trunks and Railway Express parcels. Note the incorrect spelling "Eire."

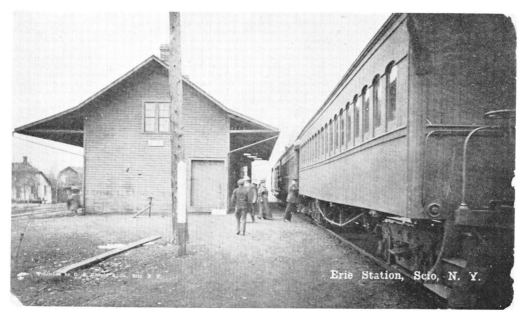

Erie Station, Scio, N. Y.

Scio is on the Erie main line in western New York, just north of Wellsville. Local legend has it that the name is an acronym derived from "Section 10" of the Erie Railroad, but the fact is that it appeared on local maps a couple of decades before the Erie was built. Therefore, it's much more likely that the name comes from the island off Greece, much in the same manner as did so many place names from the classical Greek and Roman era. Names of individuals as well as geographical spots in the Mediterranean region were assigned to many places in upstate New York: Syracuse, Rome, Ithaca, Varna, Lodi, Ovid, Ulysses, Carthage, and Homer are typical examples.

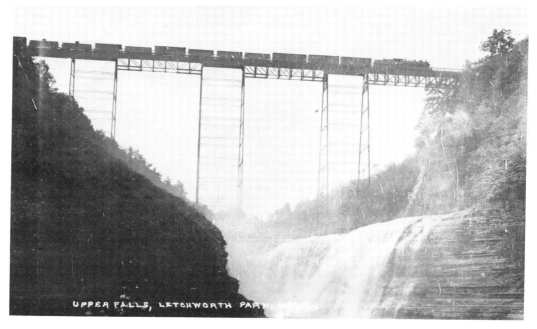

UPPER FALLS, LETCHWORTH PARK

Towering 234 feet above the upper falls of the Genesee River at Letchworth Park is this bridge on the main line of the Erie Railroad's Buffalo Division. It replaced an equally huge wooden trestle known as the Portage Viaduct that burned in 1875; it's still in use. The original wooden structure was close to 900 feet long, 1,600,000 linear feet of timber and 50 tons of iron were used in its construction, its cost was $175,000, and it took two years to build. The first train went over it on August 9 of 1852. The replacement steel structure was built in 47 days!

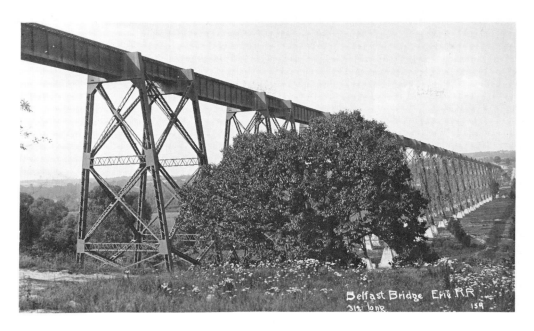

The Erie Railroad enjoyed a relatively level route between New York and Chicago, but in western New York, this was accomplished at the expense of numerous bridges. The Belfast Bridge was especially notable because of its size. In the early 1900's, the railroad constructed the Hunt Cutoff, between Hunt Junction on the Buffalo main line and Cuba, on the main east-west line to alleviate heavy grades for freight trains between Cuba and Hornell. This iron bridge, crossing the Genesee Valley, was 3,000 feet long. When Conrail took over the Erie-Lackawanna in 1976, it abandoned this stretch of track, and the bridge was subsequently dismantled.

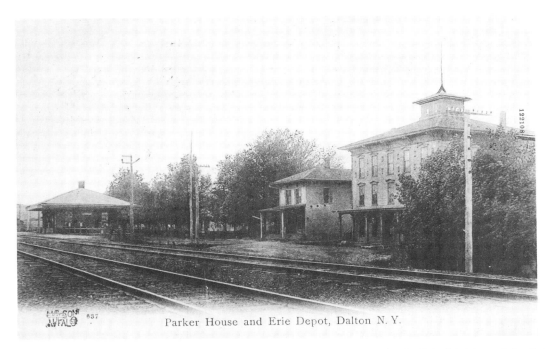

Parker House and Erie Depot, Dalton N. Y.

Typical of the myriad of small communities served by railroads was Dalton, on the Buffalo Division of the Erie, in Livingston County. As was usual in those days, a hotel was located adjacent to the station. These hotels catered not only to summer tourists, but to traveling salesmen as well, who were generally referred to as "drummers" or "travelers." Whiskey salesmen in particular were called "whiskey drummers," and representatives of piano factories were always "piano travelers."

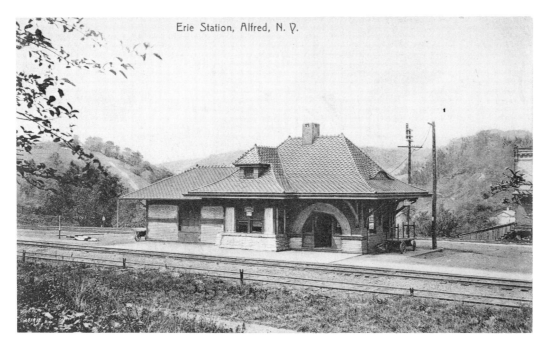

Erie Station, Alfred, N. Y.

Some communities got better stations than others, depending upon the influence they had on the railroads. Although Alfred is a small village in the Southern Tier, the Erie Railroad saw fit to erect this substantial station of brick, stone, and tile roof construction to suit the tastes and needs of a college community. Alfred University was founded in 1857 by the Seventh-Day Baptist Church; it remains independent of political control although it administers the State University College of Ceramics. It was joined in the community in 1915 by a State two-year Agricultural Institute, which now is part of the SUNY system of two-year colleges. This card was mailed in 1910.

ERIE RAILROAD DEPOT

Bird's Eye View of Allegany, N. Y. 1909

greetings from Allegany.

Emily.

Allegany is a small community just west of Olean, near the junction point of the Erie and the Western New York and Pennsylvania, a branch of the Pennsylvania Railroad. The Erie is on the far side of the station in this view while the Pennsy is in the foreground. At its peak in the 1870's, the town boasted two tanneries, two breweries, a planing mill, a sash factory, and an assortment of gristmills, sawmills, and machine shops.

36

This enormous "mallet"-type engine was one of three built by the American Locomotive Company for the Erie in 1907, specifically for use as "pushers" to help heavy trains up the grade from Susquehanna across the Starrucca Viaduct to Gulf Summit, from whence the trains proceeded to Binghamton. They were the largest engines in the World at the time, and received a great deal of publicity. They were notorious for wanting more steam than the boiler could readily produce, and they always needed two firemen as they were not fitted with mechanical stokers. Note the wide "Wooten" firebox, designed to use slow-burning anthracite coal by having a very large grate area. A later development of this series led to the famous "Matt H. Shay," a huge 425-ton locomotive with three sets of driving wheels (known as a "triplex" arrangement) named for a well-known Erie locomotive engineer.

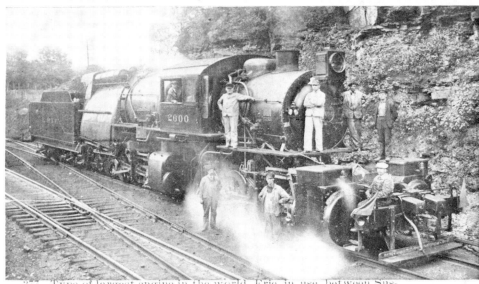

247—Type of largest engine in the world, Erie, in use between Susquehanna, Pa., and Gulf Summit, N. Y.

Anatole Mallet was a Frenchman who first developed the idea of a locomotive with its frame built in a manner to permit a large machine to negotiate short radius curves. The engine has two sets of driving wheels, and the front set is hinged to as to permit them to swing to the right and left underneath the boiler. These Erie machines were built as "compound expansion engines" in which high pressure steam is first sent to the rear cylinders; the partially expanded steam from them then goes to the front cylinders where it expands further and more work is extracted from it. The cost of maintenance of this compound system eventually gave the Erie reason to rebuild the three locomotives to simple expansion engines wherein steam under equal pressure is sent to both front and rear cylinders.

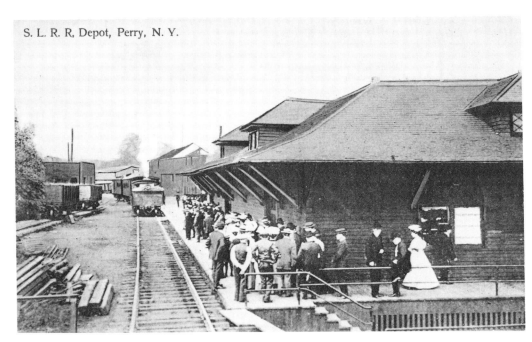

S. L. R. R. Depot, Perry, N. Y.

The five-and-a-half mile Silver Lake Railroad connected the village of Perry with the main line of the Buffalo, Rochester & Pittsburgh Railroad's Rochester division at Silver Lake Junction. The BR & P was principally a coal-hauling railroad, and it had extensive coal handling docks on the Genesee River near Charlotte, close to Rochester. The docks were used until the mid 1960's. Silver Lake was a popular resort area with a well-known Methodist campground. Passenger service directly from Rochester was discontinued in 1951, and the rails were abandoned in 1973.

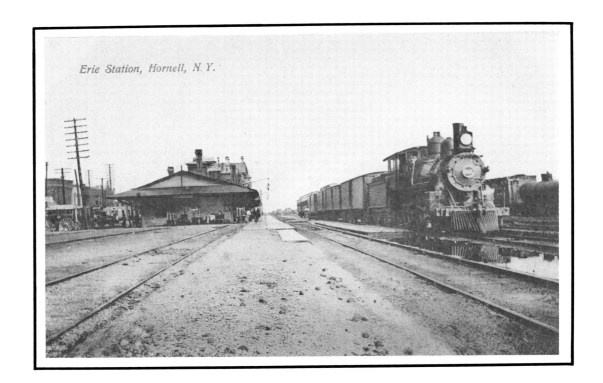

Erie Station, Hornell, N.Y.

Throughout the existence of the Erie Railroad and today's Conrail, Hornell has been an important division point. The main line continues west while the Buffalo division swings northwest. One of the most famous of Currier and Ives prints depicts this place in the 1860s, when it was known as "Hornellsville." This ornate brick station, built in 1884, housed offices of the Allegheny and Buffalo divisions; large locomotive shops were also located here.

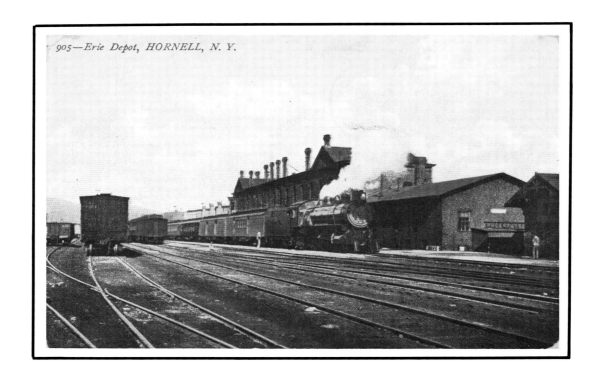

905—Erie Depot, HORNELL, N.Y.

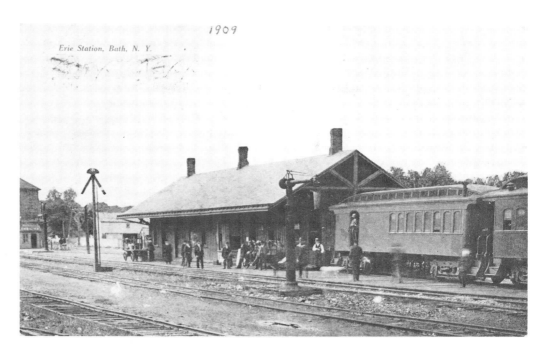

1909

Erie Station, Bath, N. Y.

Bath was located on the Rochester branch of the Erie, originally the broad-gauge Buffalo, Corning, and New York. The railroad was completed through this section in 1852, but in a few years became a part of the Erie. Passenger service ended on September 30, 1947, and the line between Corning and Avon was torn up in the 1950's and 1960's.

"Standard Gauge" railroads have their tracks four feet eight and one-half inches apart, but the Erie was built with a broad six-foot gauge. This was a most unfortunate decision because its cars could not interchange with those of other railroads; therefore its revenue traffic was slow to develop in the early years when it needed all the income it could get to cover the heavy costs of construction. After years of debate and indecision, the entire railroad was finally reworked to standard gauge. The job was completed on June 22, 1880.

Eventually, however, the "wide gauge" proved a blessing, especially during the years of World Wars I and II. The wide clearances of tunnels and structures provided in the original construction meant that oversize loads, such as cannon, could be routed via the Erie when other roads couldn't handle them.

UNLOADING ANOTHER BIG TRAIN AND ROOM FOR MORE
Cascade Park, near Springville, N. Y., on B. R. & P. Ry.

"Daisy Picker" excursions were part of the passenger trade when the Buffalo, Rochester & Pittsburgh Railroad was in its prime in the early 1900's. Cascade Park, near Springville, was popular with picnickers from nearby Buffalo.

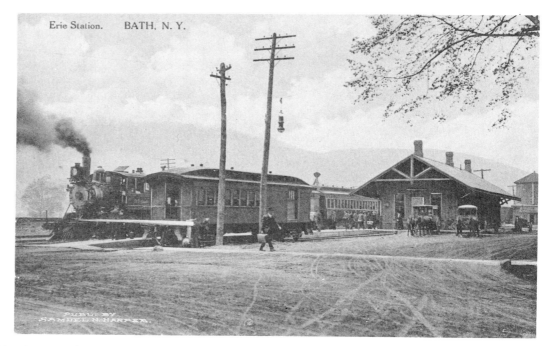

Erie Station. BATH, N. Y.

Another view of Bath shows a passenger train being pulled by a "Mother Hubbard" or "camelback" locomotive. Bath, the county seat of Steuben County, was established in 1793 as a trading post for New York's Southern Tier. Note the interesting "combination" coach and baggage car on the siding and the gas light hanging from the utility pole, as well as the horse-drawn wagons and the water tank.

Steam locomotives with the engineer's cab straddling the midpoint of the boiler were called "camelbacks" from their presumed resemblance to the animals that have a hump on the top of their torso; the term "Mother Hubbard" apparently stems from the concept of the engineer being tucked in a wooden cupboard of limited space, away from the more normal operating position with the fireman at the rear of the boiler. These engines were designed to burn slow-burning grades of coal, which, in turn, required a large, wide firebox that left little or no room for the usual engineer's position.

The Bath and Hammondsport Railroad, which connects at this point, at this writing is still very much in business.

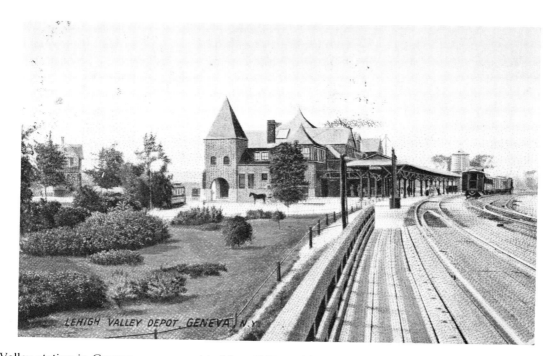

LEHIGH VALLEY DEPOT GENEVA, N.Y.

The Lehigh Valley station in Geneva was opened in May, 1893, and had a dining hall in its early years. The engineering office for this division of the railroad was quartered upstairs; to the rear of the building, the Naples branch veered south. The station was closed with the cessation of passenger service in 1961 and was later used to quarter freight train crews before being sold to private interests. Note the horse and the trolley car.

40

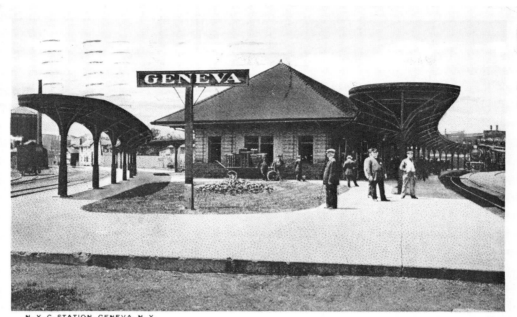

N. Y. C. STATION, GENEVA, N. Y.

In the early 1900's, the New York Central built this station near the junction of the Corning branch (left) and the Auburn road (right). It was used until 1958. Historic Geneva is the home of Hobart and William Smith Colleges and the New York State Agricultural Experiment Station.

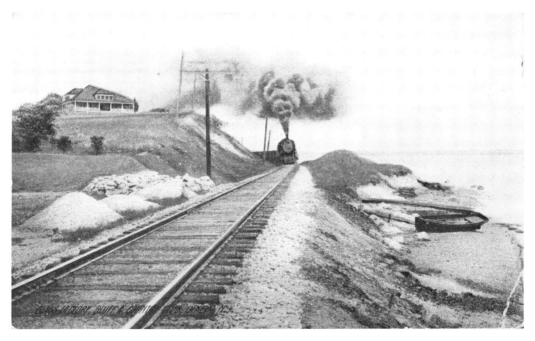

In this pre-1910 scene a southbound train scurries south along Seneca Lake just below Geneva at a place called Glass Factory Point. This was primarily a coal-hauling route from Pennsylvania. In later years, after this photo was taken, the line was double-tracked.

When today's rail buffs have the rare opportunity to see a coal-fired steam locomotive in action, they love to photograph great plumes of black smoke emanating skyward and the engineer and fireman operating the fan trip are usually more than willing to oblige and put on a great show. But the fact is that excessive smoke generally means improper management of the fire and wasted fuel; for that reason train crews in the old days of steam were under constant pressure from management to minimize smoke. Coal-fired locomotives spread black soot everywhere they pass; in the old days those who lived and worked adjacent to the tracks were destined to carry out their lives amid dirt and grime.

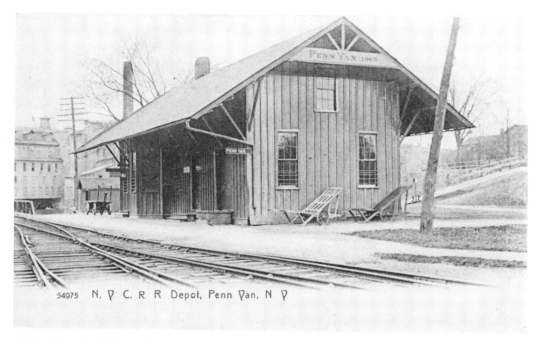

54975 N. Y. C. R. R. Depot, Penn Yan, N. Y

The New York Central operated a seven-mile-long branch line built on the old towpath of the Crooked Lake Canal between Dresden and Penn Yan for many years. The railroad operated a mixed train over the line until 1953; in later years, the few remaining passengers often rode in the caboose.

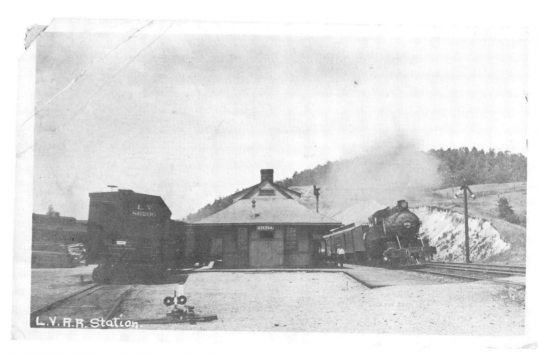

Odessa was located on the Lehigh Valley main line north of Van Etten Junction. Here the railroad started north along Seneca Lake's east shore. Major lumber and coal dealers were located in the area, and the station also served the local agricultural community.

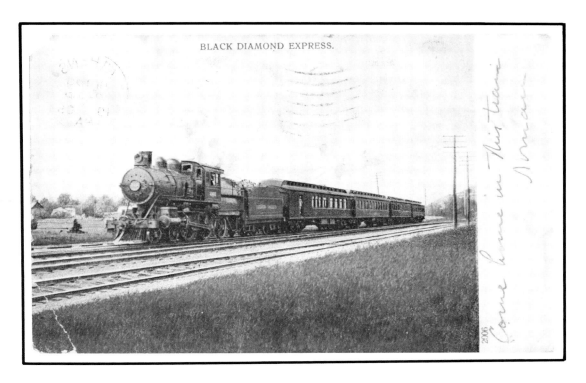

The *Black Diamond Express* was the showcase train of the Lehigh Valley Railroad; service with what was called "The Handsomest Train in the World" was inaugurated on the run from New York City to Buffalo via Ithaca and Geneva (with connections to Philadelphia) on May 18, 1896. Only the best rolling stock available at that time was used to equip the train. Its final run was on May 11, 1959 and in the intervening 63 years it provided a marvelous service for patrons everywhere on the line, in spite of stiff competition from parallel railroads operating between New York City and Buffalo. In the Railway Guide for 1930, which includes timetables for all American roads, the Black Diamond's 24-seat, observation lounge/sunroom parlor car is noted as featuring Stock Market Reports—a useful service for business-oriented travelers.

An early description, undoubtedly prepared by the line's public relations experts, said that "The lead car is a combination baggage and cafe car outfitted with a library and smoking room for gentlemen. . . . Kitchen and dining facilities are to the rear of the car, presided over by chefs whose culinary artistry [excells] in preparing and serving substantials and delicacies in most appetizing fashion." This post card view of the diner is a real rarity, showing not only the galley, but one end of the sumptuous service area with its potted plants, Pintsch gas lamps, and clerestory windows.

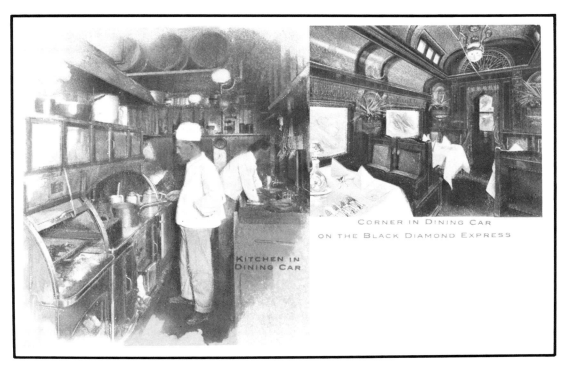

Ithaca's passenger terminal on the Lehigh Valley Railroad was one of that road's busiest station in passenger traffic—thanks to the large number of Cornell students who traveled to and from New York City. It was opened in 1898, built by Driscoll Brothers to the designs of architect A. G. Wood. An admirable service provided for many years by the railroad was having a Pullman sleeping car spotted at the station, available for boarding after 9 p.m. New York-bound travelers could go to bed anytime after that hour and awaken in New York

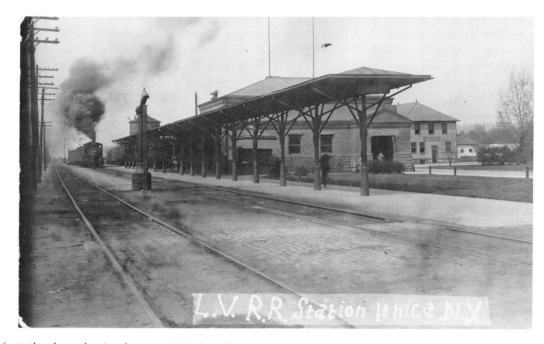

City, just in time for breakfast, thanks to having been switched to the east-bound train in the middle of the night. Somehow today's travel, with all its high technology, doesn't seem quite as luxurious.

One of your writers recalls that in the 1930's there were two cars assigned to this service named *Scenic Highlands* and *Scenic Ravine*, appearing on the siding to the right of the locomotive in this view on alternate days. Pullman cars all had names, with the character of the name denoting the interior arrangements of the sleeping accomodations.

For years, the station has continued to serve the public as a fine restaurant, and the owners have been careful to preserve many of the original artifacts from the days of steam. One of the writers has fond recollections of many hours spent around this station during his high-school days, watching trains and absorbing railroad lore.

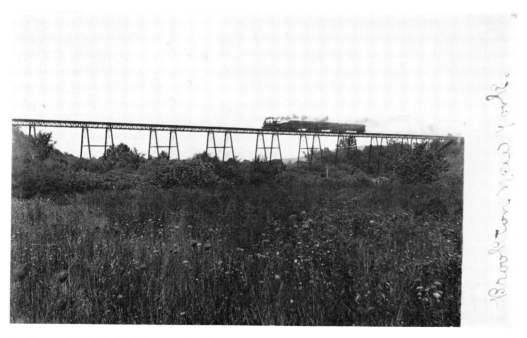

Ezra Cornell, the founder of Cornell University, invested an estimated $2,000,000 of his own money (which he made from developing a special plow that could trench and bury the wires for Samuel F. B. Morse's newly-invented telegraph, and his subsequent investments in Western Union Telegraph stock) in the Ithaca and Cortland Railroad. It became part of the Elmira, Cortland and Northern, which around 1905 became the EC & N division of the Lehigh Valley Railroad, popularly known as the "Empty, Crooked, and Nasty," or sometimes the "Empty Cars and No Train." It extended from Elmira to Camden, New York, passing by Brookton (now known as Brooktondale) on the way, just six miles east of Ithaca. The road passed over this 800-foot-long, 85-foot high- steel viaduct which was constructed in 1894 to replace one of wood built in 1875. This card was posted on September 24, 1907 from Brookton to a lady in Elmira, with no message; it was simply signed 'Lovingly', Alice. And it cost all of a 1 cent postage stamp to get it there!

Service on the line between Van Etten and East Ithaca ended in 1935, and this structure was dismantled soon thereafter.

For years, a big part of the annual "Spring Day" festivities at Cornell University in Ithaca was the traditional crew race between the Ivy League colleges on a course close to the east shore of Cayuga Lake. The Lehigh Valley Railroad capitalized on public interest in the event by running on its Ithaca-Auburn branch a special train of gondola cars fitted with bleachers to seat hundreds of spectators. By this means it was possible to follow the entire length of the race as seen here looking north toward McKinney's. The umbrella at the lower right suggests the possibility of rain; note the conductor at the lower left of this card, which was postmarked in 1907. This train was operated as early as 1899, and its last run was in 1936. A locomotive with a Wooten firebox capable of burning anthracite coal was often used to minimize the smoke nuisance to the patrons of the run.

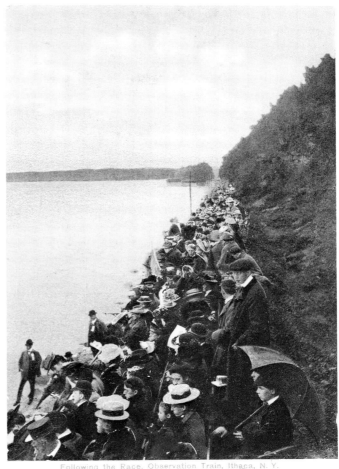

Following the Race, Observation Train, Ithaca, N. Y.

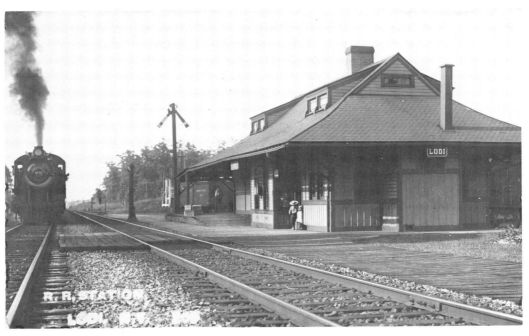
Lodi was on the Lehigh Valley's main line on the east side of Seneca Lake. This line was favored for most of the Lehigh's freight traffic, in order to avoid the stiff grades encountered on the more easterly line that ran through Ithaca.

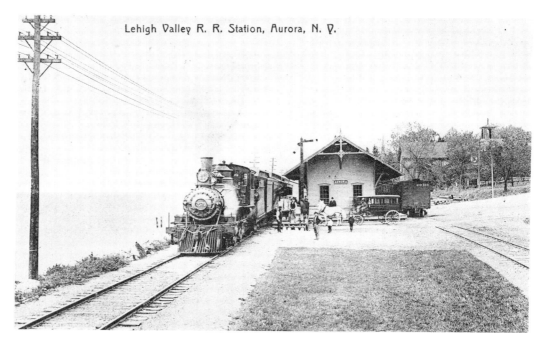

Lehigh Valley R. R. Station, Aurora, N. Y.

The Lehigh Valley had many branch lines in upstate New York. Aurora was located on the Auburn and Ithaca branch, which ran along the east shore of Cayuga Lake. It is the home of Wells College for Women, founded by Henry Wells who made his fortune in the Wells-Fargo freight business which was prominent in opening the American West. One of your writers has pleasant memories of riding this line between Aurora and Ithaca in the 1930's when it was served by a gas-electric motor car built by Cleveland's Electro-Motive Corporation. It is said that in the old days when the moon was bright the conductor would turn out the coach lights so that passengers could more fully enjoy the scene on the lake.

Part of this line survives as a Conrail branch that brings many thousands of tons of coal each week from mines in Pennsylvania, by way of Ithaca, to be converted to electricity by the Milliken Station of the New York State Electric and Gas Corporation. Much salt is mined under Cayuga Lake, and it starts its way to market on this scenic section of rail.

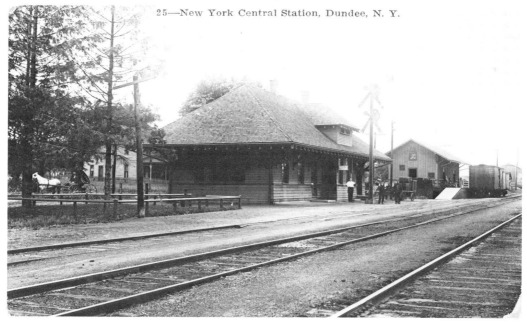

25—New York Central Station, Dundee, N. Y.

Dundee is on the former "Fall Brook" line of the New York Central which extends southward from Geneva. This is one of the railroad's more scenic lines in the upstate area with a panoramic view of the heart of the Finger Lakes for the passengers to enjoy. Regular passenger service was discontinued in the early 1930's; since then, numerous excursion trains have traversed the route. This station, built about 1910, was razed in 1981.

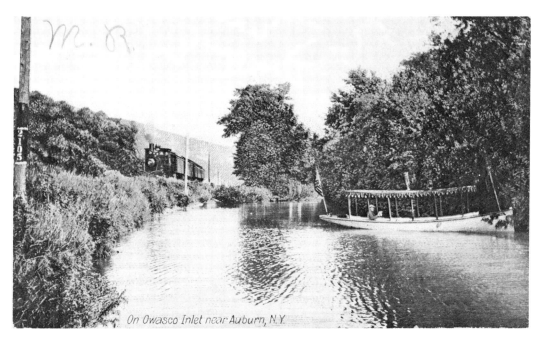

On Owasco Inlet near Auburn, N.Y.

A pleasant summer day in the early 1900's finds the local Lehigh Valley passenger train heading south along the Owasco Lake inlet enroute to Sayre, Pennsylvania. This view is near Moravia. Small naphtha-fueled launches, such as the one in this view, were common in those days. The narrow beam and canvas canopy were typical features of boats of the era.

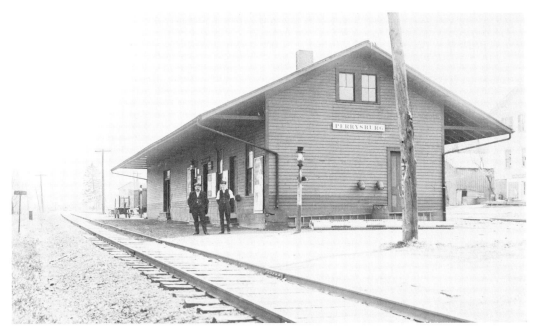

Perrysburg was located on the old main line of the Erie, about 20 miles south of Dunkirk. The Erie operated three passenger stations daily in each direction between Dunkirk and Hornell at the time this photo was taken in the early 1900's. This portion of the railroad is now abandoned.

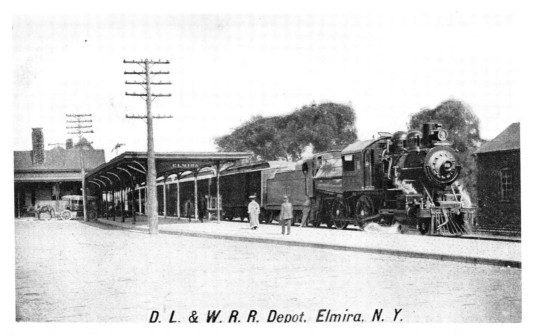

D. L. & W. R. R. Depot, Elmira, N. Y.

The DL & W's first station in Elmira was built in 1882 when the main line was constructed to Buffalo. A new stone station was built in 1913, and was used until August 30, 1959, when passenger service over this segment of the line ended as trains were diverted to the Erie. The tracks were elevated through the city in 1932.

When the Erie came to Elmira in 1849, it was the longest railroad in America, stretching from Pierpont on the Hudson River to Dunkirk on Lake Erie. Its tracks were six feet apart—a specification for which the road became famous, although they were eventually changed to the the four-feet-eight-and-one-half inches adopted as the US standard. President Millard Fillmore was a passenger on the first train, along with his Secretary of State, Daniel Webster. Webster passed the journey seated in a rocking chair fastened to a flat car, better to witness the scenic

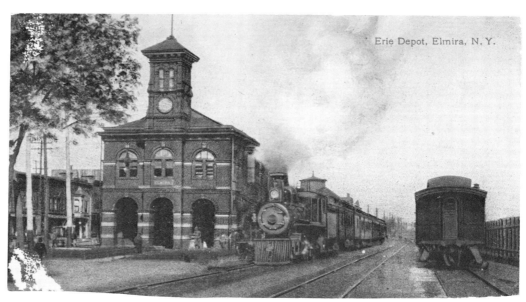

Erie Depot, Elmira, N. Y.

beauties of New York's Southern Tier. Elmira was connected by rail to Watkins Glen in 1849 and to Williamsport in 1854; these roads eventually became part of the Pennsylvania Railroad system and shared the "Union Station" with the Erie as seen in this 1895 postcard. In later years, it was known strictly as the Erie Station, though the two roads shared trackage in the city and on the Chemung River bridge. In the 1930's when the track was elevated through the downtown district, the second floor became the main passenger accomodation. Around the turn of the century, 67 passenger trains stopped daily (except Sunday) in Elmira, divided among this station, the Elmira Cortland and Northern (Lehigh Valley) and the Lackawanna, each of which had their own depots.

This station was erected in 1875 and was used by the Erie-Lackawanna until 1966.

The Southport yards of the Pennsylvania Railroad were established in Elmira in 1886 and remained active into the mid 1960's when coal traffic stopped to Sodus Point on Lake Ontario. This was on the Pennsy's line between Williamsport and Sodus, which was originally a segment of the Northern Central Railway. Besides the normal facilities for servicing steam locomotives, there also were extensive freighthouses and an ice station. Today, barely a trace of this yard exists.

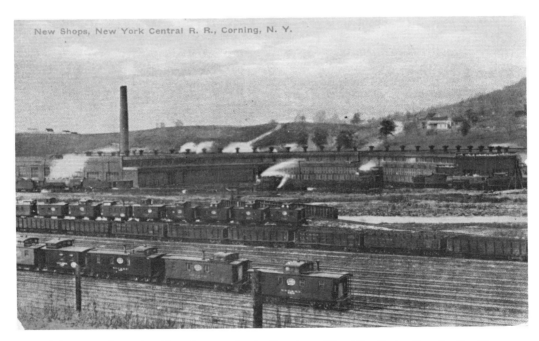

Corning is one of the more historic railroad towns in the Southern Tier. The first railroad—the Tioga—was completed to Lawrenceville, Pennsylvania, in 1833. By the mid-1970's, an extensive network of north-south rail lines connected the Pennsylvania coal regions with upstate New York. The extensive shops and yard in this view were established in the 1880's just north of the city and remained active until the early 1950's. Note the line-up of four-wheeled cabeese.

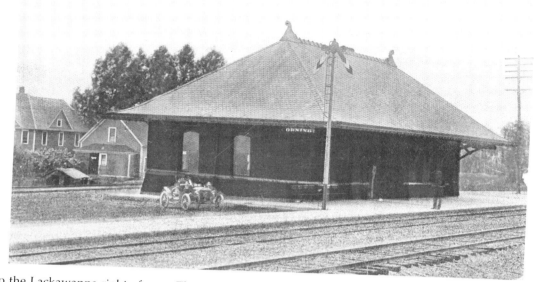

One of the writers was employed by the Corning Glass Works during 1950, and since he lived nearby had the pleasure of watching this station being moved as part of the Erie relocation project in Corning. The Erie tracks were removed from their course down the length of Denison Parkway, the main drag of the city, to the north side of the Chemung River, adjacent and parallel to the Lackawanna right-of-way. The job involved moving this brick Lackawanna station about 150 feet to the east, rotating it 180 degrees, and setting it on a new foundation. To the experienced building movers who handled the task it probably was just another routine job, but to the uninitiated observer it surely seemed a monumental task to hustle down the street such a substantial brick building as was typical of DL & W construction. Not many years afterwards, the Erie and the Lackawanna merged; had this been foreseen at the time a good deal of money could have been saved by not having to duplicate all the trackage and attendant facilities.

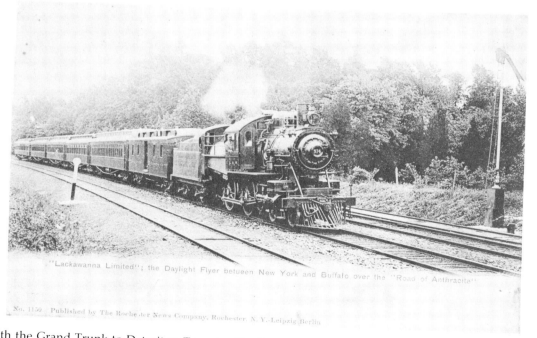

"Lackawanna Limited"; the Daylight Flyer between New York and Buffalo over the "Road of Anthracite"

No. 1150. Published by The Rochester News Company, Rochester, N. Y.-Leipzig-Berlin

One of several crack passenger express trains on the DL & W was the *Lackawanna Limited* which operated between Hoboken, New Jersey, and Buffalo, where connections were made with the Nickel Plate Road west to Chicago, or with the Grand Trunk to Detroit or Toronto. The DL & W was known for its fine service for generations, and its most famous name train was the *Phoebe Snow* (especially in later years) with the *Lackawanna Limited* a close second for recognition by the public. In the days when this photo was taken, trains typically consisted of "Mother Hubbard" locomotives with wooden passenger cars.

Note the truss rods under the cars, a necessary part of structural support for wooden cars before steel underframes were developed. In the old days, tramps and "hoboes" would frequently steal rides on freight cars with truss rods by lying on planks put across them, at right angles to the track—thus the term "riding the rods."

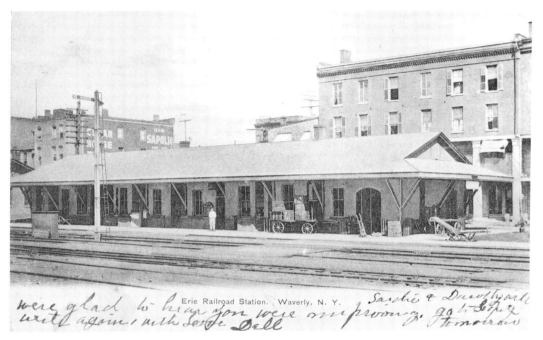

were glad to hear you were improving. *Sadie & Dorothy will*
will again, with *large* *Dell* *go to Sayre tomorrow*

The Waverly station was erected in 1879, replacing an earlier structure built in 1865 during the Civil War. Waverly, a real railroad town, was also served by the Lackawanna and the Lehigh Valley.

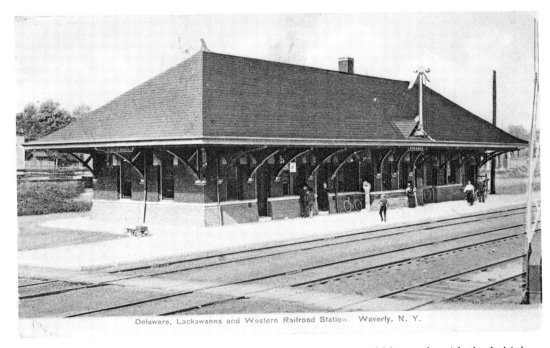

A new brick station was built by the Lackawanna at Waverly in 1905. Here, connections could be made with the Lehigh Valley Railroad, which had extensive shop facilities located at Sayre, Pennsylvania, just two miles to the south. This card was postmarked in 1908, so the picture was taken when the building was brand-spanking-new. Note the penny scale located near the entrance; such equipment was once common in public places and stores all over the nation. The Taft Museum in Cincinnati, Ohio, in 1983 published an interesting book titled *The American Weigh* that chronicles their use over the years.

Quaker Oats once had a large plant in Waverly, and near this scene was a stock yard and a large ice house.

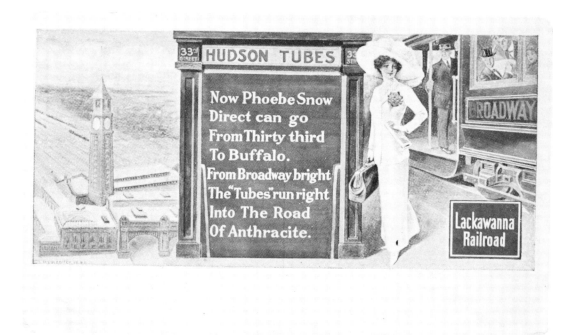

Phoebe says, and Phoebe knows
That Smoke and Cinders spoil good clothes—
'Tis thus a pleasure and delight
to take the Road of Anthracite.

One of the most successful advertising and public relations campaigns in railroad history involved "Phoebe Snow," an attractive young lady always dressed in white who, at least in theory, always arrived at her destinations every bit as clean as when she started. The Lackawanna Railroad burned anthracite or "hard" coal, which made for a lot less smoke and soot as products of combustion, thus offering passengers a much cleaner ride than they could expect from traveling on a competing line using soft coal.

For years, starting in 1901, the road used jingles such as these to put its message across to the public, and the campaign is credited with having increased DL & W patronage by 80 percent by 1910. The fact that the Lackawanna had the shortest route between New York and Buffalo also helped to attract passengers.

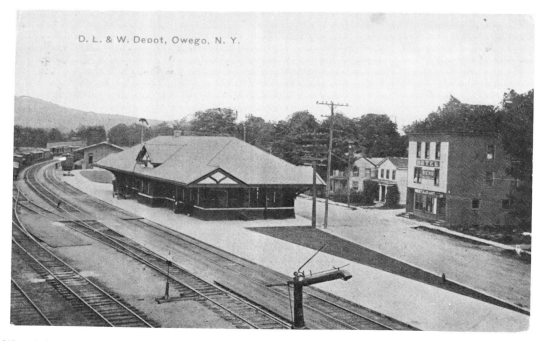

This DL & W mainline depot at Owego was built in 1905. From here, the Ithaca branch extended northward across an eight-span bridge over the Susquehanna River that stood until 1959 when that line was abandoned. In the 1960's after the merger of the Lackawanna and the Erie, New York State Highway 17—the "Southern Tier Expressway"—was built on the right-of-way of the abandoned DL & W main line from Vestal, 12 miles east, westward through here to Corning.

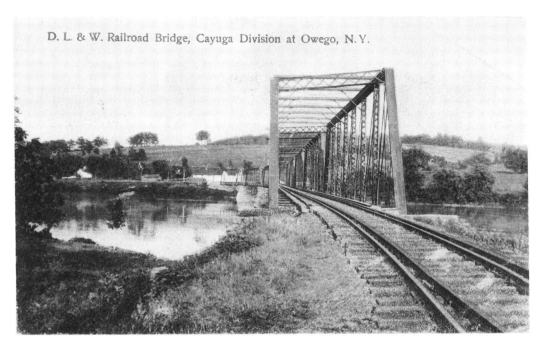

D. L. & W. Railroad Bridge, Cayuga Division at Owego, N.Y.

This view shows the DL & W bridge at Owego looking south across the Susquehanna. The spans curve toward the east at the far end. Owego was the southern terminus of the Ithaca and Owego Railroad, which opened for traffic on April 2, 1834. This branch, which eventually became part of the Lackawanna, was a horse-drawn road for the first six years of its existence.

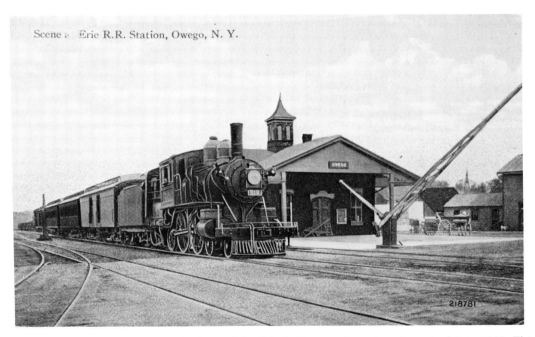

Scene at Erie R.R. Station, Owego, N. Y.

One of the most historic communities along the line of the Erie is Owego; the railroad reached it in 1849. This station was completed in 1879, replacing an earlier building that burned in 1874. The station still stands and is privately owned.

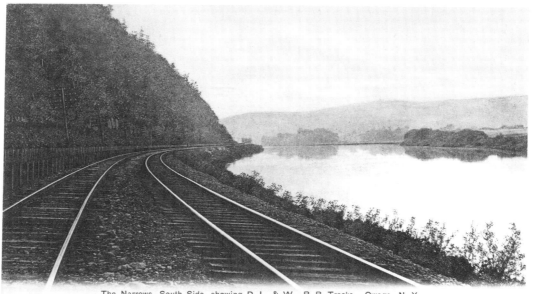

The Narrows, South Side, showing D. L. & W., R. R. Tracks. Owego, N. Y.

From the comfort of their automobiles today's highway travelers enjoy this pleasant scene on the south side of the Susquehanna River just west of Owego. Slabs of concrete and the asphalt of New York State's route 17—the "Southern Tier Expressway"—have replaced the steel rails.

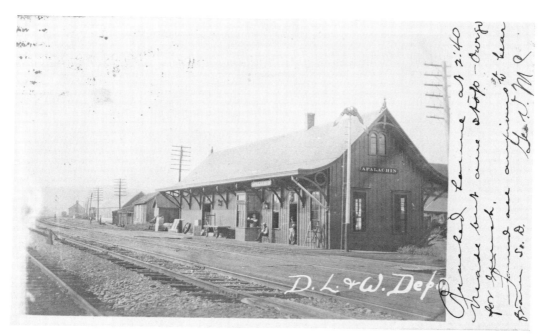

When the Lackawanna Railroad constructed a major straightening and re-alignment of its main line track between Scranton and Binghamton during the years 1912 to 1915, a distance of 3.6 miles was cut off, and 2400 degrees of curvature were eliminated. The new route was so much more efficient than the old that the $14,000,000 cost was recovered very quickly. This has nothing to do directly with Apalachin, except to point out that the State of Pennsylvania built much of highway Route 11 on the old railroad bed, and several of the original stations remain today serving as roadhouses of one sort or another. . . so even now, as you drive this scenic route you can see surviving examples that are sisters to this Apalachin Station built in 1882. When new it was painted a rust red, and adjacent was a stock yard for the benefit of local farmers sending livestock to market. It was replaced by a sturdy brick structure in 1912, and at this writing this one remains close by New York's "Southern Tier Expressway" (Route 17) which was built on the DL & W roadbed westward from Vestal for several miles after the railroad had merged with the Erie and all rail operations were moved to the Erie tracks across the valley.

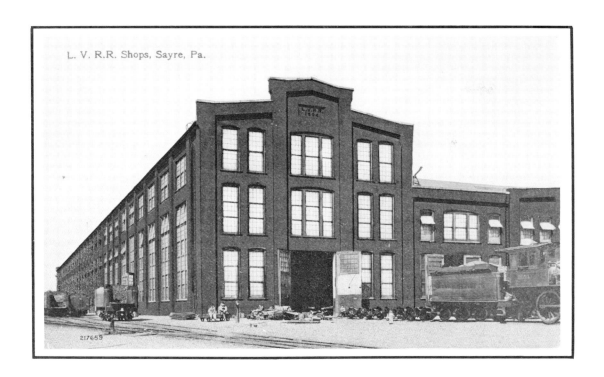

L. V. R.R. Shops, Sayre, Pa.

217659

In 1904, the Lehigh Valley reconstructed its shop facilities in Sayre, Pennsylvania, and built this enormous two-bay shop building with two erecting halls. The Lehigh also maintained a large engine house and extensive car shops here, as well as a power house. The last vestiges of these shops, which were used until 1976, were demolished in 1988.

The interior view below gives an idea of the size of the Lehigh's operation at Sayre; the road at one time even built its own locomotives here.

Strictly speaking, Pennsylvania scenes don't belong in a book on New York State railroads, but the Sayre shops which were just across the border played such a significant support role for Lehigh operations throughout New York it seems appropriate to include them. Besides, these are views to bring tears to the eyes of hard-core steam locomotive buffs!

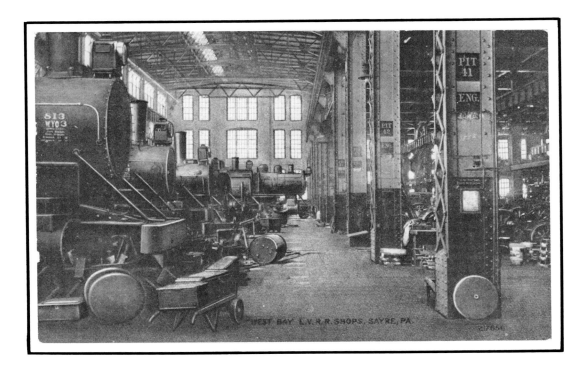

WEST BAY L.V. R.R. SHOPS, SAYRE, PA.
217656

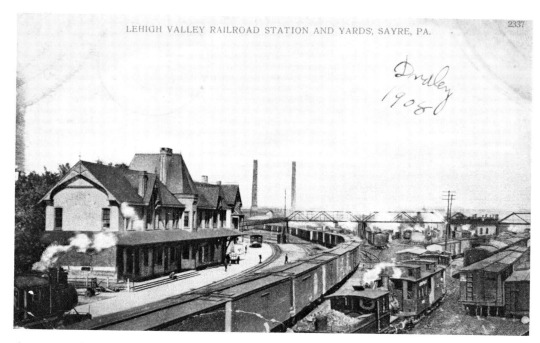

Sayre was once the center of activity for the Lehigh Valley's Seneca division, and it was surely a busy place back in 1908 when this card was mailed. The station, still standing, was built in 1882, replacing an earlier structure that burned. As this writing, the building houses the Valley Railroad Museum upstairs, and an attractive restaurant on the ground floor. The Lehigh Valley Railroad was absorbed into Conrail in 1976.

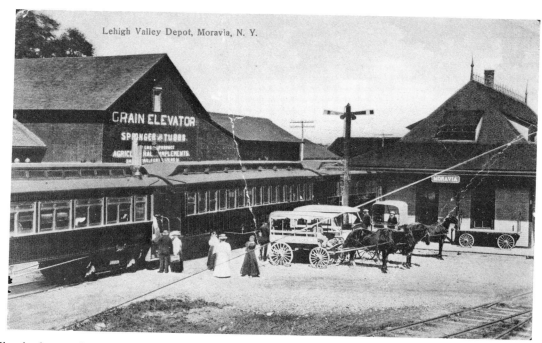

Lehigh Valley Depot, Moravia, N. Y.

The Lehigh Valley had many branch lines that wandered throughout upstate New York; Moravia was located on the Auburn Branch that ran from Sayre, Pennsylvania. The northern terminus was Fair Haven, where coal was transhipped by lake steamer to Canada and ports throughout the Lake Ontario region. The coming of the railroad brought growth and prosperity with it.

In the old days, railroads were maintained by section gangs such as this one, which typically were responsible for maintaining the track and switches on 10 to 20 miles of road. This is the so-called Willow Creek section gang on the Lehigh Valley; note that the handcar on which they are so neatly posed is the good-old-fashioned hand-pumped variety. We may assume that the kids in front are just there for the picture; the railroads were not known for profiting from child labor. Willow Creek was at milepost 313.7, which puts it at just 6.6 miles west of Ithaca, whose milepost was 307.1.

These human-powered vehicles were sometimes called "Irish Pullmans," recognizing the many Irish immigrants who toiled on railroad track gangs.

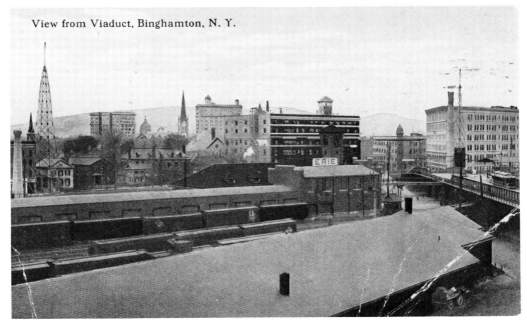

For years, one of the most popular vantage points for railfans in Binghamton has been the Chenango Street viaduct over the area fondly referred to by some as "Malfunction Junction." The area was an interchange between the Erie, the Delaware and Hudson, and the main line and the Syracuse branch of the Lackawanna; in addition, connections were made here to the Lehigh Valley in Owego. The viaduct in this view, on which a nifty monitor-top trolley car is seen, was replaced by a modern structure in the 1970's. Note the steel tower at the left—it's a radio tower that was installed by the Marconi Company in 1913, and it still stands at this writing, as do the other railroad structures in the view. Marconi pioneered the use of the "wireless telephone" (today, we call it "radio") on railroads throughout the world.

57

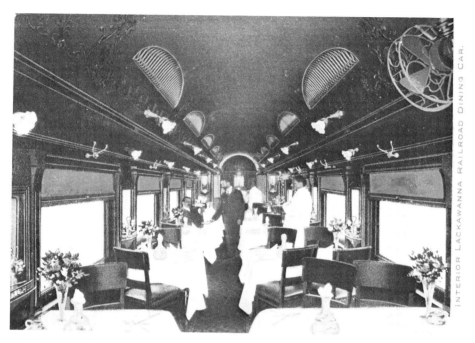

INTERIOR LACKAWANNA RAILROAD DINING CAR.

Like most railroads, the Lackawanna furnished elaborate dining car facilities in the early 1900's—and for that matter, right up until the end of passenger service in 1970. The road enjoyed the reputation of offering a superb cuisine for its travelling patrons, and many will say that few pastimes compare with the pleasure of consuming a sumptuous meal while enjoying the passing scene through the windows of the diner—then, or now. The lyricist of the famed song *Chattanooga Choo-Choo* put it well: "Nothin' could be finer; dinner in the diner."

"SUNBEAM", SODUS POINT, N.Y.

Back in the days when the trains met the steamboats the Sodus Bay Line of the Pennsylvania was a popular route for travelers on vacation or just going for a summer afternoon outing. Here the *Sunbeam* awaits the arrival of a passenger train at Sodus Point.

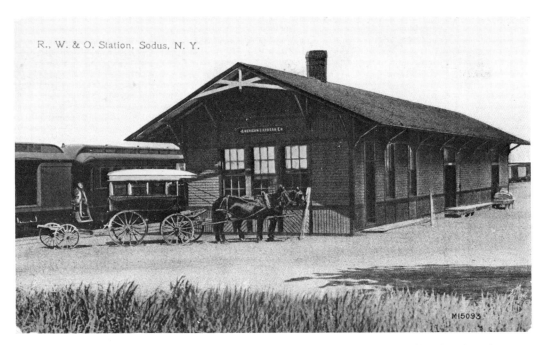

M15093

Today, Sodus, 38 miles east of Rochester, is headquarters of the Ontario Midland Railroad, a company formed to take over portions of former New York Central and Pennsylvania branch lines in the area. Most of these stations were constructed by the Rome, Watertown and Ogdensburg prior to being merged into the New York Central. Note the two-wheeled baggage trailer attached to the depot hack.

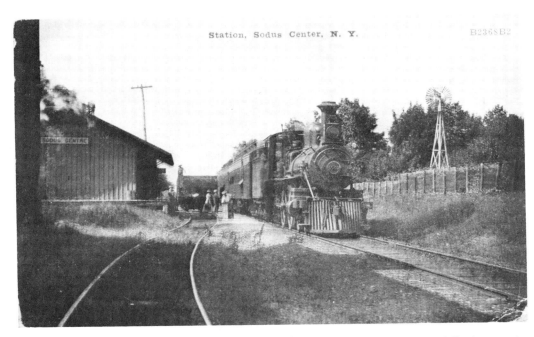

Station, Sodus Center, N. Y. B2368B2

Sodus Center, north of Newark, is deep in the heart of the Wayne County fruit farming area, a region especially famous for apple production. The railroad line was formerly a part of the Pennsylvania's Sodus Bay branch.

LAKE SHORE STATION, GREAT SODUS BAY, N.Y.

During the summer months, the Pennsylvania Railroad operated passenger trains directly to Sodus Bay, about a mile from the permanent station. Passenger service was discontinued to the point in this postcard view in 1929, and to Sodus Point station in 1935.

HISTORIC CABOOSE IN NEAHWAH PARK, ONEONTA, N. Y. 79

The Brotherhood of Railroad Trainmen is alleged to have been founded in this little four-wheeled caboose on September 23rd, 1883; from Oneonta, it grew to prominence as a labor union for the many thousands of men who worked to keep the arteries of commerce humming with train movements all over America on the rapidly-expanding network of rails that followed the Civil War. For years after it left active service, this caboose served as a tool shed in the southern end of the Delaware and Hudson yards. In 1924 it was moved to Neahwha Park where today it serves as a monument to the hardy breed of men who devote themselves to the iron wheel on the steel rail. Note the lettering on the side of the car: "D & H C Co" stands for "Delaware and Hudson Canal Company" and "A & S RR" for "Albany and Susquehanna Railroad," the name of the original road from Albany to Binghamton. There is a question as to whether the original meeting actually took place in the car, but what matters is that it serves as a fine historic symbol for the founding of the organization.

Cabooses with only four wheels went out of style around the turn of the century. Typically they were rough-riding affairs, and were known to railwaymen as "bobbers."

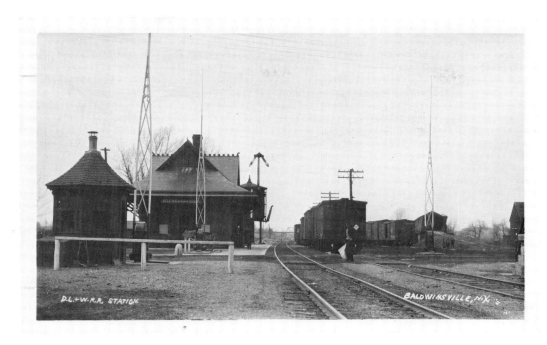

Baldwinsville, on the DL & W's Oswego branch, boasted a typical wooden station similar to others on the Lackawanna Railroad which obviously were based on a common set of architectural plans. In this community, the road served a small creamery, a coal company, International Milling Company, Morris Pumps, and several other local firms.

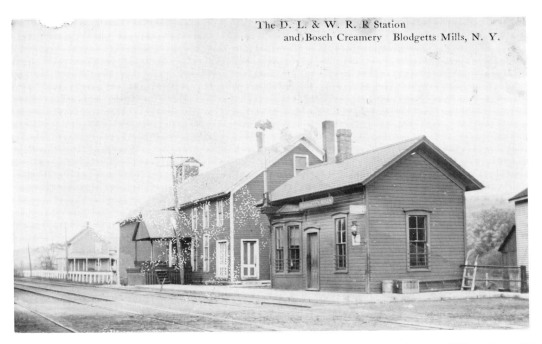

Blodgetts Mills is a hamlet on the former Syracuse branch of the Lackawanna between Cortland and Marathon. This small station, which looks just cute enough to be a child's backyard play house, served the Bosch Creamery and the feed mills located here. It was an important stop on the railroad more than a century ago in the days when agricultural products from small communities provided significant revenues for the railroads. Today it's on the Delaware Otsego System.

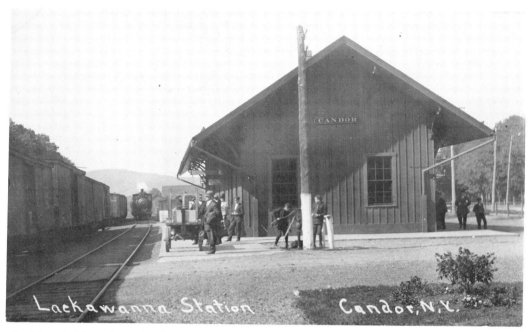

Candor was on the historic Ithaca branch of the Lackawanna about 10 miles north of Owego. At one time, the line served a Borden creamery, a stock yard, a coal dealer, and two feed and fertilizer dealers. The line was abandoned in 1956, and the depot has since been replaced by a bank.

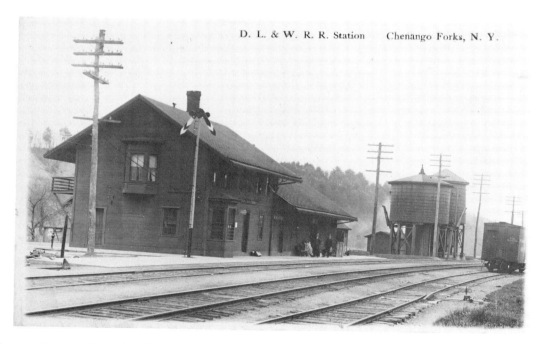

Chenango Forks was the junction point for the Syracuse and Utica branches of the Lackawanna, and was a very busy location for many years. The agent and his family lived upstairs in the depot, as was common practice through the early 1900's. Besides two water tanks, there were ice houses, feed, coal, and lumber company sidings here. Chenango Forks is 11 miles north of Binghamton; the depot was demolished in the mid-1970's.

In a letter to her son Earl Robinson, then a student at Amherst College in Massachusetts, his mother described the scene at Chenango Forks, just north of Binghamton, in May of 1907: "What a fire occurred at C. Forks this afternoon. A special went up just ahead of the 9:59 express set fire to the creamery. It got such a start before anyone saw it, it burned the ice house's creamery. [note the large stacks of ice—ed.] Tuttle house next to Tom's and Tom's barn are in ruins. The fire company from Greene came, had it not been for their time and the street from Willard's would of been in ruins. Charley Smith's house got afire every window light in the front of the house is cracked. . . .

"That same special set fire to the Stillwater Creamery this P.M. and that burned. Tom has sent a dispatch to Greene says he will know by tomorrow what to do with the milk."

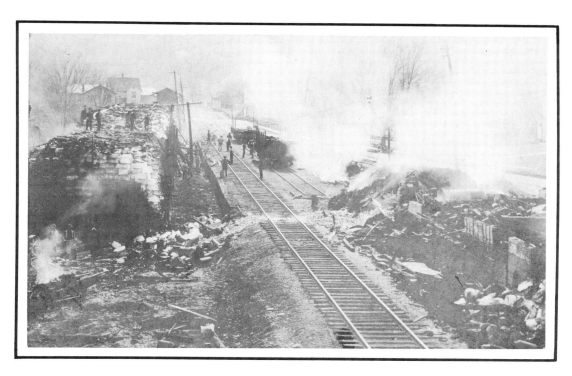

Still another ice house at Chenango Forks on a postcard mailed in 1909. Before the days of mechanical refrigeration, buildings like these were common across the land. They housed ice in blocks packed in sawdust, cut from local lakes and ponds in the winter months. From the buildings, the frozen water was shipped to market throughout the year to find use in homes, institutions, restaurants, and any commercial establishments requiring food and other commodities to be kept at low temperatures.

The tunnel at Tunnel, New York, just east of Binghamton, on the Delaware and Hudson Railroad. A pitched battle took place here on August 10, 1867 when the forces of rail magnates Jim Fisk and Jay Gould were warring over control. This fracas played a major part in the famed novel *Saratoga Trunk* by Edna Ferber, and it was depicted in the movie of the same name produced by Warner Brothers in 1943. One of the authors has pleasant memories of seeing the film, which starred Ingrid Bergman and Gary Cooper, while seated on a bomb-crate in a makeshift "theatre" on the island of Guam in 1945. It was a restful interlude from carrying out his duties as a mechanic on Air Force B-29 aircraft during the unpleasantness of the Pacific war.

In the mid-1980's, an enlargement project was undertaken at a cost of about $19,000,000 to permit double-stacked container cars to pass through this restriction on the line after careful engineering analysis showed that this was the least costly of three options. The other possibilities were to (1) re-route the track around the hill, or (2) to open the tunnel to daylight. At one point the tunnel is some 90 feet under the surface of Belden Hill.

Alert observers who have examined the tunnel will recognize that the negative which was used to print this view was "flopped," for from this vantage point the track veers to the left, not the right.

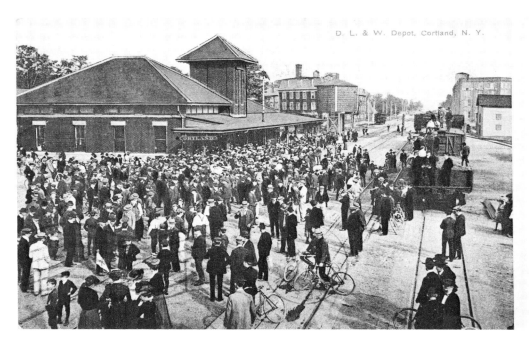

It seems incredible that the once-busiest locale in Cortland is now the most forgotten. This elaborate passenger station was built in 1903, and once served as many as eight passenger trains a day. Cortland was one of the most important stations on the Lackawanna's Syracuse Division; local businesses included Wickwire Brothers Steel, Brockway Motor Truck Company, Titchener (which in later years made automobile parts), Crystal Ice Company, and numerous feed, coal and lumber companies as well as a canning company and a slaughter house. The writer of the card, who mailed it on October 19, 1909, gives no hint in her message as to why this crowd was gathered.

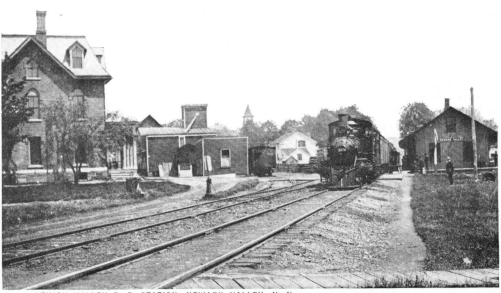

LEHIGH VALLEY R. R. STATION, NEWARK VALLEY, N. Y.

Newark Valley was a station on the Lehigh Valley's Auburn division running from Sayre, Pennsylvania, to Fair Haven on Lake Ontario. At the time of this writing a portion of the line runs between Owego and North Harford as the Tioga Central Railroad; it serves not only as a common carrier for some businesses along the line, but also as a tourist attraction. One of the writers has pleasant memories of a fine meal served aboard its dining car while enjoying the beautiful scenery of a 25-mile long part of picturesque New York State.

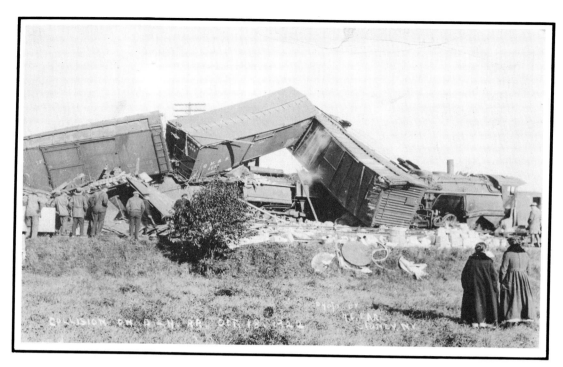

Three scenes of a tragic pile-up on the Delaware and Hudson Railroad at Sidney, New York, on October 18, 1922, at 4:55 in the early morning hours. Engineer William P. Toal of Binghamton was killed in the wreck and his fireman, Clyde Casey of Binghamton, was injured.

According to the account in the *Binghamton Press*, the D & H train smashed into the side of an Ontario and Western freight that had been halted in the Sidney yards and was just leaving a switch. ". . . Father E. A. Dougher administered the last rites of the Catholic Church. Engineer Toal died within half an hour after the wreck. Fireman Casey was found under the wreckage near the rear of the locomotive, but the weight of the debris had been held off him and he was suffering only from minor bruises."

The *Press* waxed indignant about the lack of interest on the part of the railroad in informing the public:

"D. & H. officials in this city and Oneonta, with their usual reticence regarding happenings on the road, refused today to give out any information regarding the wreck. Officials in this city, as late as 10:30 o'clock, at first denied that they had heard anything of a wreck, and later refused to say anything regarding it or to tell even the number of the trains or the names of the crew, saying that any information would have to come from the division offices in Oneonta. Oneonta officials when called on the telephone refused to say anything beyond admitting that a wreck had occurred, declaring that they were under orders not to divulge any details concerning any accident that occurred on the road."

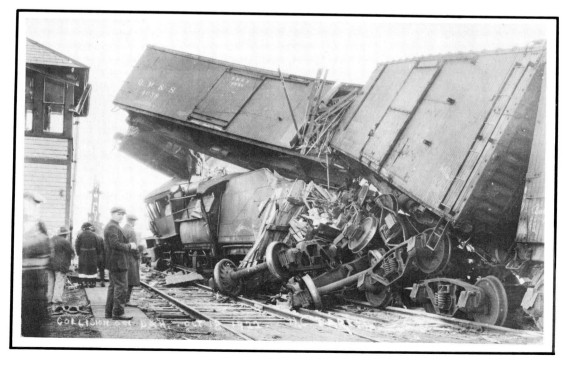

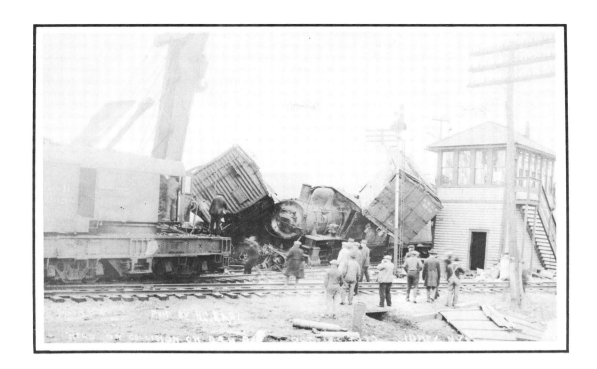

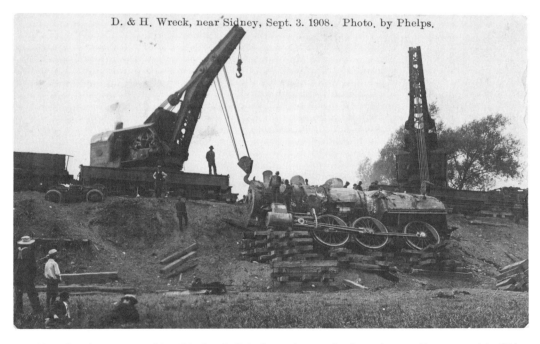

D. & H. Wreck, near Sidney, Sept. 3. 1908. Photo. by Phelps.

The D & H was obliged to bring two of its "big hooks" (railway jargon for large locomotive cranes) to Sidney to clean up this splendid mess when the engineer, a chap named Dimmick from Binghamton, failed to slow from 50 miles per hour at a temporary crossover where repairs were being made. The mishap to passenger train No. 2 took place around 11 A.M. on September 3, 1908; fortunately no one was seriously injured. After applying the brakes, the engineer jumped from the cab when the train was still going about 35 miles per hour. The fireman, George Quindle of Binghamton, was thrown through the window of the cab.

The account in *The Binghamton Press* goes on to tell us that ". . . the baggage car and express car left the rails and followed the engine down the bank, but did not turn entirely over. The baggageman, W. G. Everett of Binghamton, was pinned under a lot of baggage when the car finally tipped over on its side but was not seriously injured. . . the smoking car left the rails, and the passengers in it were thrown about and more or less bruised. The last coach did not leave the rails at all."

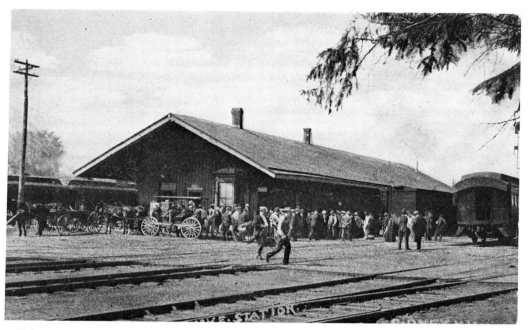

Sidney was the division point on the New York, Ontario, and Western, between the northern and southern divisions. Here, the O & W tracks crossed those of the Delaware and Hudson, and both companies used this station. Operation of the O & W ceased on March 29, 1957.

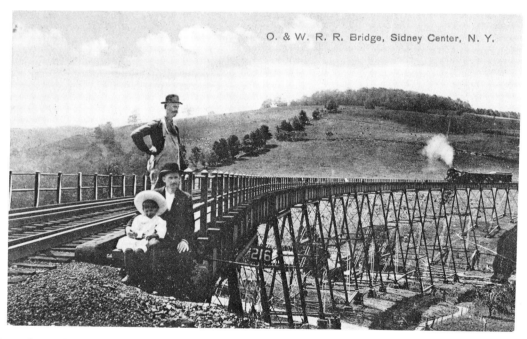

It was a time when fathers derived great satisfaction in taking their children down to see the railroad in action. Kids are always entertained by seeing machinery in motion, and the belching steam and flying soot from a steam locomotive combined with the fascinating mechanisms connecting the driving wheels, the steam cylinders, and the valve gear make an irresistible combination for young and old to witness. The Ontario and Western's spindly trestle at Sidney Center was a landmark for many years.

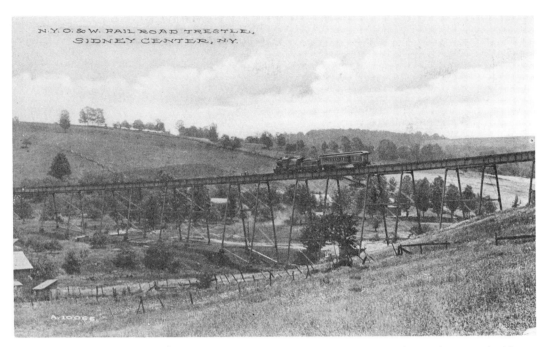

Still another view of the famed O & W trestle at Sidney Center, supporting an obviously unprofitable one-car train. It has been said that the O & W was the largest railroad that started nowhere, ended nowhere, and didn't go anyplace between! Even so, it somehow managed to stay in business about 100 years before economic realities caught up with it.

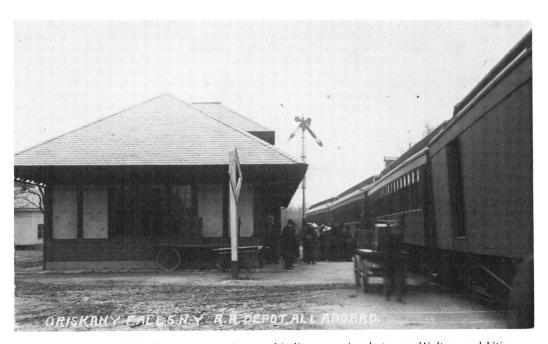

Oriskany Falls was on the Utica Branch of the O & W. Passenger service on this line, running between Walton and Utica, was discontinued on April 27, 1930. In later years, service was provided by a gasoline-powered motor car. This card, postmarked in 1913, carries on its back side the heading "Beach's Real Photograph Post Card—Genuine Hand-Finished—Made from any photo at Remsen, New York." It's a typical example of a photo-card made by a small-town studio.

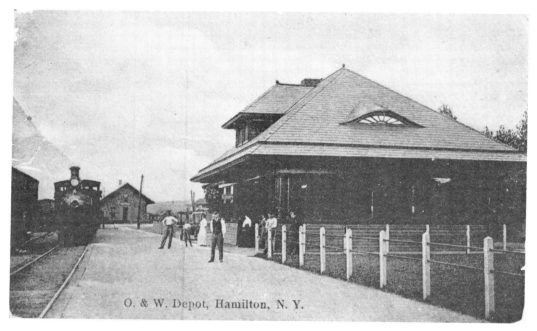

O. & W. Depot, Hamilton, N. Y.

Long after regular passenger service had vanished from the O & W's Northern division, occasional "specials" were operated to Hamilton for Colgate University students. The original depot, seen in the distance, was converted to a freight office. The new station, in the foreground, with its interesting "eyebrow" dormer was erected in the early 1900's. Both structures still exist.

The message on the card, written to one Mabelle Shaver in Madison, New York in 1913, is:

"Dear Mabelle—i will be home on the milk it gets to Solsville about 4 o'clock just as soon as you get out of school come down to meet me goodby love to all - from Maud."

Nothing earth-shaking about this, but it reveals that the locals evidently referred to the afternoon train as "the milk." For many years, the hauling of milk from upstate New York to the metropolitan market provided significant revenues for the New York, Ontario, and Western Railway.

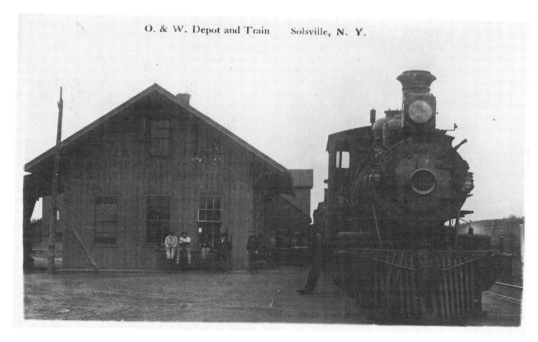

O. & W. Depot and Train Solsville, N. Y.

Solsville, referred to in the previous view, is a small rural community located on the O & W between Bouckville and Oriskany Falls on the Utica branch. Could it be that this locomotive is hauling "the milk?"

Solsville had a cheese factory, as did many such communities, which collectively did their part in making the dairy industry a major factor in the economy of New York State.

The message on the back, written to a Miss Mildred Canfield in Utica in 1910, is: "O You next two-step -- from Vernon Jones." We might well imagine that this is part of a courtship between the two wherein he is suggesting a date for the next neighborhood dance. The "two-step" was a very popular dance routine of the era. Two-steps, one-steps, and ragtime were all the rage.

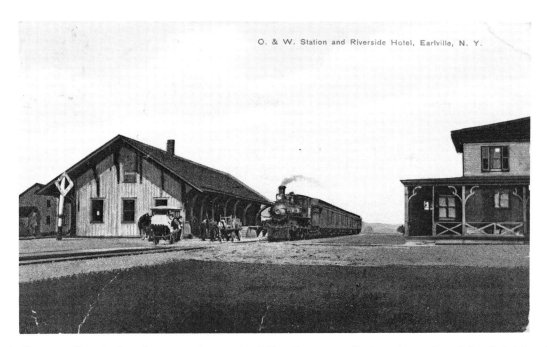

O. & W. Station and Riverside Hotel, Earlville, N. Y.

Earlville, a small agricultural community south of Hamilton, was the junction point of the O & W and the New York Central's Chenango branch, which ran from there through the countryside to Syracuse. At one time the O & W's crack passenger train the *Chicago Express* was switched to the Central at this point.

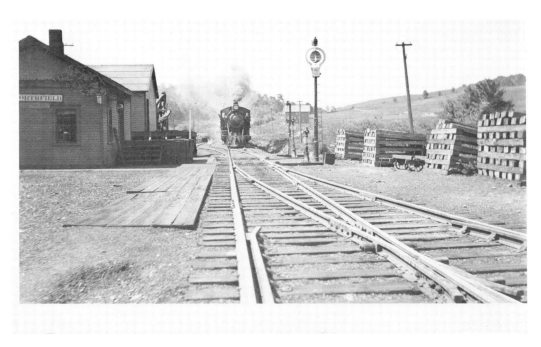

Between Sidney and Walton, the New York & Oswego Midland Railroad, predecessor of the New York, Ontario and Western, built a switchback over Northfield Mountain whereby trains could be switched back and forth over manageable grades to reach the summit. In time, this became an intolerable nuisance, so in 1890 a tunnel was bored. Although the tortuous switchbacks were eliminated, water freezing in the tunnel became another another problem that had to be alleviated by the installation of a steam system to melt the ice. Notice the old-fashioned signal at the right.

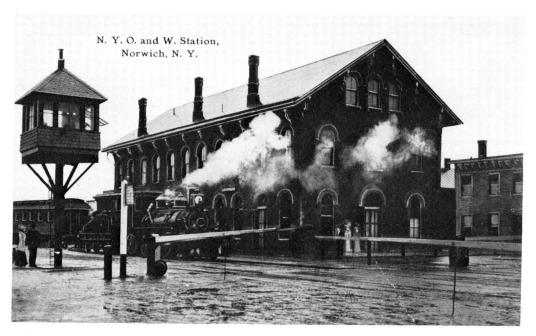

N. Y. O. and W. Station,
Norwich, N. Y.

The most important point on the northern division of the O & W was Norwich, one of the larger cities on the line, where extensive shops and other facilities were maintained. Here, the line paralleled and also competed with the Lackawanna. In the 1870's, the Auburn branch was extended from Norwich to DeRuyter and beyond, a piece of construction that was doomed to economic failure from the very start.

At this writing, a watchman's shanty-on-a-pole like the one in the foreground has been preserved in Norwich though it's from the Lackawanna Railroad. Two others exist in New York State; one remains in active use on Schuyler Street in Utica.

106—Lyon Brook Bridge, Near Norwich, N. Y.

The famous Lyon Brook bridge on the New York, Ontario & Western south of Norwich was 1,200 feet long and stood 156 feet high. It was erected in 1869 and was just one of the railroad's engineering marvels.

Milk train south bound Munns N.Y.

The O & W relied too heavily on the many small agricultural communities it served that simply didn't generate enough revenue to justify the road's existence. In this splendid action shot taken on a cold morning many years ago, the southbound milk train passes through Munnsville, ("Munns" on the card) south of Oneida, leaving a dandy plume of white vapor. Note that the train consists of three milk cars and a "combination" car that accomodated both baggage and passengers.

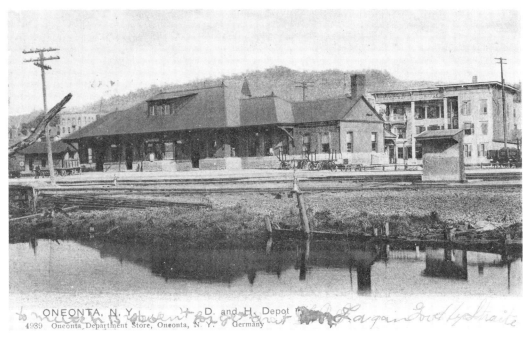

ONEONTA, N. Y. D. and H. Depot
4939 Oneonta Department Store, Oneonta, N. Y. Germany

Oneonta, on the Delaware and Hudson, hasn't seen regularly scheduled passenger service since a bitterly cold January 24 in 1963 when the last train made its farewell trip from Binghamton to Albany and back. At one time Oneonta was the home of enormous shop facilities of the D & H with some 5,000 employees toiling to keep the road's equipment in shape.

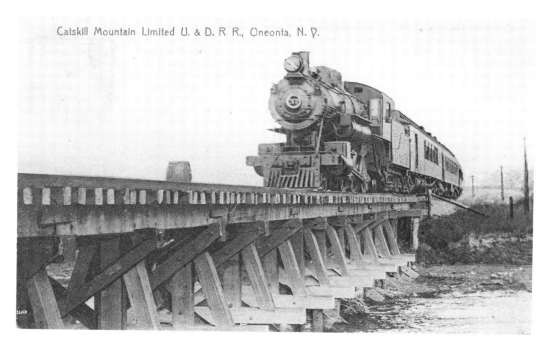

Catskill Mountain Limited U. & D. R R., Oneonta, N. Y.

In his outstanding book *The Ulster and Delaware … Railroad Through the Catskills*, Gerald Best identifies this train as the *Rip van Winkle Flyer* while this postcard of the identical scene says it's the *Catskill Mountain Flyer*. Whichever it is, by 1908 the U and D had five name trains; the other three were the *Mountain Express*, the *Day Line*, and the *Ulster Express*. The *Catskill Mountain* featured Pullman observation and parlor cars, one of which had a buffet section providing top-notch accomodations for passengers traveling from Weekawken, New Jersey, to the terminus at Oneonta.

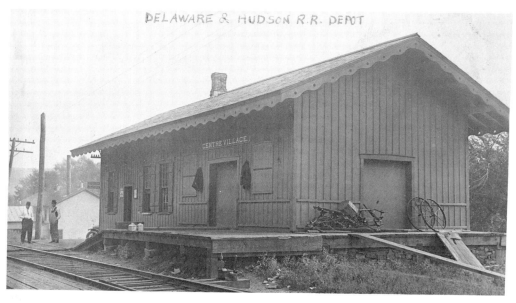

DELAWARE & HUDSON R.R. DEPOT

In some communities, the railroads built combined passenger and freight terminals such as this one on the D & H at Center Village, 89 miles north of Scranton on the road's Pennsylvania division and just a few miles east of Binghamton.

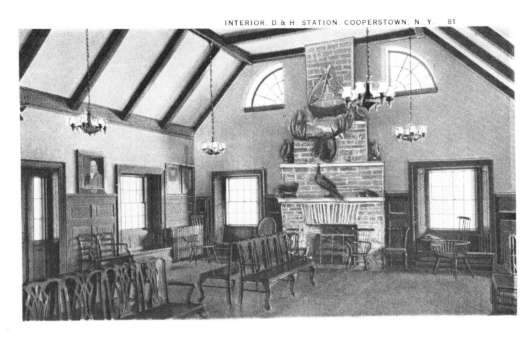

One of the more elaborate branch line depots was this structure built in 1916 in Cooperstown, 16 miles from the Delaware and Hudson railroad's main line. It was built to serve patrons of the railroad's O-Te-Sa-Ga Hotel, a popular resort for the well-heeled; today it is a private home. Its style was in keeping with the historical significance of the community, known to history buffs everywhere as the home of novelist James Fenimore Cooper. Today, Cooperstown is well-known among baseball fans throughout America as the home of the Baseball Hall of Fame.

The New York, Susquehanna and Western (better known as the DO Line, (from Delaware and Otsego)— a highly-successful short line put together in the 1960's and 70's from the pieces of a number of roads in New York, Pennsylvania, and New Jersey—has its headquarters here in Cooperstown.

Greetings from Colliersville, N. Y.

Colliersville, on the Delaware and Hudson, is one of those little old-fashioned resort communities Grandma used to visit in the summer time when, as the saying goes, "the world was young."

D. & H. Station, Worcester, N.Y. Belle m R

Worcester was a small stop on the Delaware & Hudson main line between Binghamton and Albany. Note the elaborate gingerbread-style depot.

One of the writers was privileged (if such a journey can be considered a privilege) to ride the last passenger run on this route in 1963. One of the passengers was an elderly lady who told him that she simply had to take the ride for sentimental reasons as she and her late husband had started on their honeymoon trip half-a-century earlier on the very train. What memories it must have brought to her, for the clothing styles of the time were probably much like these in this view, and the local transportation to and from the hotels on the route likely was by horse-drawn depot hacks just as these seen here.

L. V. R. R STATION. Locke, N.Y.

The station at Locke along the Lehigh Valley's Auburn branch primarily served an agricultural community. It was still in company service in the 1960's, but after the rails were pulled up in the mid-1970's, it became a storage barn for a nearby feed mill.

Mount Beacon acquired its name from the signal fires that were burned on its summit during the American Revolution to warn Colonial forces of British advances upriver. In 1902 the Mt. Beacon Inclined Railway was built on the west side of the mountain facing the Hudson River, affording a spectacular view in clear weather. A trolley line ran from Fishkill Landing (later Beacon) through the village to the base of the Incline, and a casino was built at the top for dining and

Matteawan, N.Y. Climbing up Mt. Beacon,

dancing by river excursionists who journeyed to the summit. The Incline was plagued by fires through the years and finally closed in the early 1970's. Part of the wooden structure of the Incline is still visible at this writing.

In 1910 this card was posted, carrying the following message:

"Dear Father—Here is a picture of the greatest incline railway in the World. It is a beautiful ride. Best wishes, Elmer.

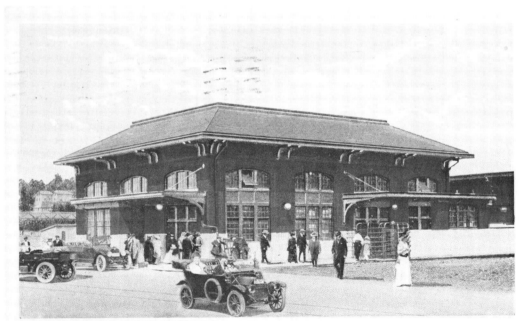

N. Y. CENTRAL R. R. STATION, BEACON, N. Y.

Located about 58 miles north of New York City on the Hudson Division of the New York Central, this brick station at Beacon was likely built at the same time (1924) as some four-tracking work was done between here and Chelsea, one station to the north. An earlier station was a large two-story structure that served both the New York Central and Harlem River, and the Central New England. The latter line was derived from the Dutchess and Columbia, and later, the Newburgh, Dutchess & Connecticut. The station was adjacent to the ferry slips of the Newburgh-Beacon ferry, which ceased operation with the building of the Interstate (I-84) highway bridge in 1963. The station also served Newburgh on the opposite bank of the Hudson since the West Shore division of the New York Central offered less frequent service. Beacon remains as a station stop in commuter territory served by the Metro/North Commuter Railroad, but the building itself is gone. The earlier name for this station was Fishkill Landing, but in 1913 the community combined with Matteawan to become Beacon, named after nearby Mount Beacon. In the good old days Albany/Troy express trains stopped here, but very few main line through trains did so.

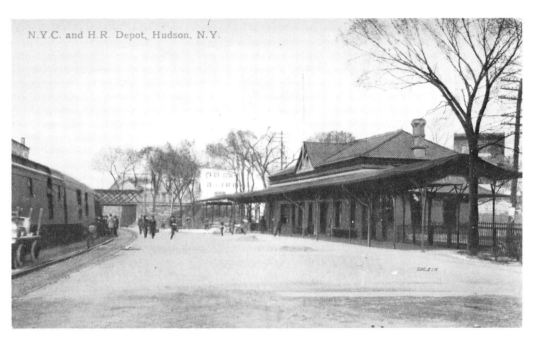

N.Y.C. and H.R. Depot, Hudson, N.Y.

The City of Hudson was the first major stop on the New York Central south of Albany and the station, located on a sharp curve, is still used by Amtrak. It dates from the 1880's.

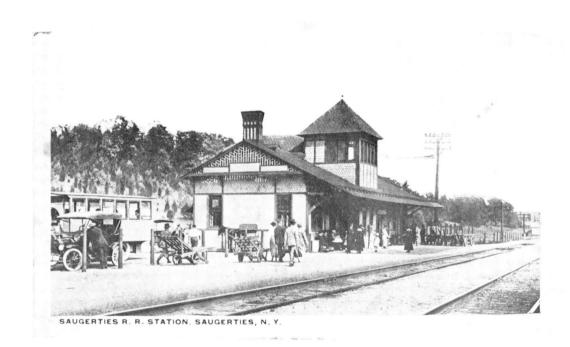

SAUGERTIES R. R. STATION. SAUGERTIES, N. Y.

Saugerties, near Kingston, was served by the West Shore Railroad which was eventually absorbed into the New York Central System. It boasted a typical Queen Anne style station characteristic of the line. Extensive brick manufacturing facilities were located here.

Notice the Model T touring car with the brass radiator, which was used by Ford through the 1915 model year. In their wildest dreams probably few officials of the railroad suspected that this was the harbinger of bad tidings for railway passenger service throughout the nation, and that Mr. Ford's vehicles were paving the way for a completely different way of life not long hence.

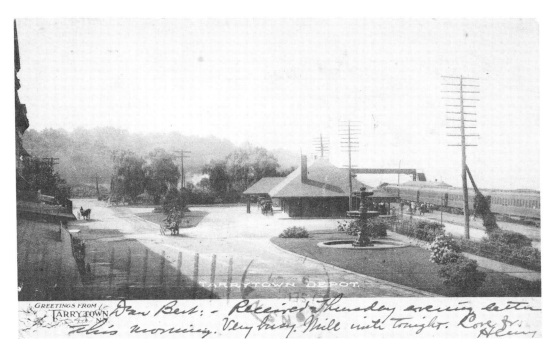

Tarrytown, on the Hudson River and close to New York City, has always been an important rail commuter stop. Note the elaborate water fountain and landscaping that was the trademark of oldtime railroading. Four horse-drawn rigs are in the picture—and not an automobile in sight! The station features a nice portico to shelter passengers from inclement weather as they stepped from or into their carriages.

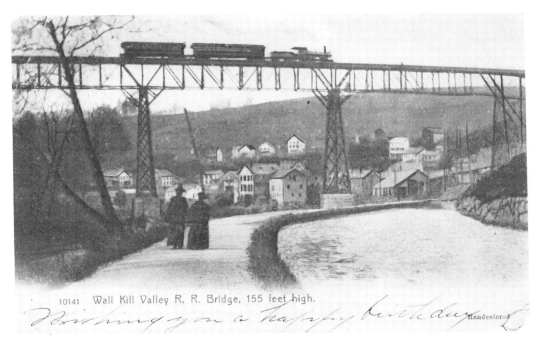

Two modes of transportation are represented here. On a spindly 155-foot-high trestle, a train of the Wallkill Valley Railroad crosses over the D & H canal meandering its way toward Kingston, New York. The railroads eventually put the canals out of business because they were faster and could be operated 12 months of the year, whereas canallers could move nothing during the winter when their waterways were frozen.

The Wallkill Valley Railroad, which eventually became part of the New York Central System, went from Kingston to Walden, New York. The Walden branch of the Erie came up from Campbell Hall and met the Wallkill Valley in Walden. The Erie branch still exists (under Conrail) but the Walkill Valley Railroad is gone.

79

Public Square, Ghent N. Y.

The public square of New York's Ghent, where "Mildred" was spending her vacation back around the turn of the century, bore little resemblance to the City in Belgium with its many medieval stone structures after which this small community was named. Ghent, located in Columbia County, was served by the Boston and Albany, and the New York Central's Harlem line.

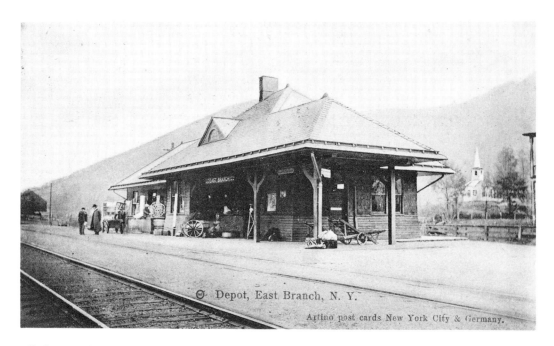

Depot, East Branch, N. Y.

Artino post cards New York City & Germany.

Before modern high-speed automobile transportation rendered railway trips for vacationers to the Catskill Mountains from New York City and return a thing of the past, East Branch, on New York's "Southern Tier Expressway" (Route 17) was an important junction point for patrons of the resort hotels of the region. The main road was the O & W, (its station seen here) which was joined at this point in 1906 by the Delaware and Eastern. It conducted operations northward to connect with the Delaware and Ulster at Arkville, 37 miles up the road along the East Branch of the Delaware River. The D & E was short-lived as a corporate entity, bankrupt after only a couple of years of operation; after reorganization its new name was Delaware and Northern. It ceased operations in the early 1940's after issuing its last timetable in September, 1941. East Branch was 152 miles from New York City as measured on the New York Ontario and Western tracks.

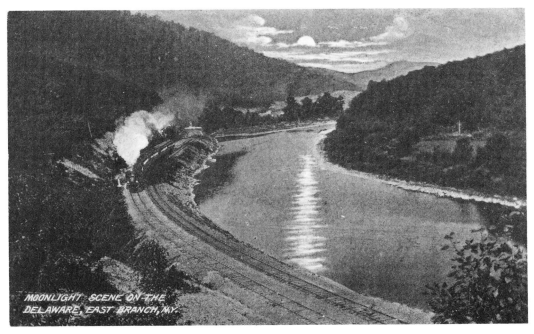

MOONLIGHT SCENE ON THE
DELAWARE, EAST BRANCH, N.Y.

Each of the fifty United States has its scenic beauties, but New Yorkers are especially blessed by the Delaware River in the lower reaches of its Catskill Mountain region. It is here that the art and sport of dry fly fishing first became popular generations ago. Whether on a beautiful moonlit night during the summer season; in the autumn when these hills are a blaze of color; in the spring when the leaves are re-appearing on the heavily-wooded hillsides, or when all was covered with snow, passengers and crew of the O & W railroad could count on beauty in every direction unencumbered by the distracting influence of heavy smokestack industries.

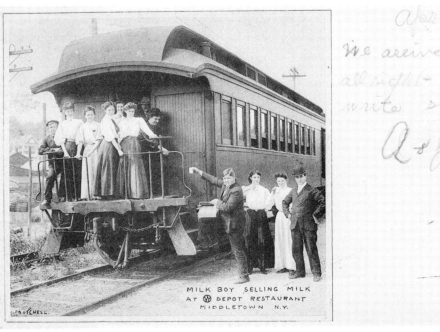

MILK BOY SELLING MILK
AT ⊙ DEPOT RESTAURANT
MIDDLETOWN N.Y.

The O & W traditionally made stops so that passengers could grab some food at local eateries, and one of the best-known of these was Seeholzer's Restaurant in Middletown which was famous for its doughnuts and pastries. It was a mad dash for those who desired such sustenance, for the train stopped only ten minutes.

Passengers who did not wish to engage in the frantic rush at Middletown could buy milk and sandwiches from "hawkers" who went through the trains or sold them on the platforms of coaches. It was often a long, dusty ride to a destination in those days, and food and drink was a welcome relief.

The card was produced by C. H. Phelps of Sidney, New York, a well-known photographer and producer of postcards in the early 1900's. This and the one on page 67 showing two locomotive cranes hauling an engine up an embankment are excellent examples of his work.

THE RIP VAN WINKLE FLYER RUNNING THROUGH THE CATSKILL MTS., N. Y.

The Ulster & Delaware Railroad provided one of the most scenic rides anywhere in the northeastern part of America as it wound 106.9 miles from Kingston Point on the Hudson River westward to Oneonta, right through the Catskill Mountains where Washington Irving's legendary mountaineer, Rip Van Winkle, had his famed 20-year sleep. The line was completed to Stamford in 1872 and Oneonta in 1900, although for some years through passenger service to connect with the Delaware and Hudson at Oneonta had been offered by a stage connection from Bloomville, 12 miles westward. In 1932, the line became part of the New York Central system; the 1970's saw the last of service except for the later tourist ride on a section of remaining track east and west out of Arkville. The U and D with its *Rip Van Winkle Flyer* and four other named trains brought vacationers for years from New York City to the mountains for a cool and refreshing respite from the heat of the summer in what we today call "The Big Apple." The railroad made possible the development of a large hotel industry along its length, patronized by guests who came to the Kingston terminus on the West Shore Railroad from Weehawken, New Jersey, or on one of the many passenger liners that plied the waters of the mighty Hudson River.

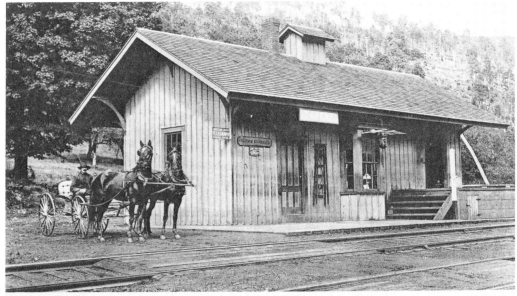

⊙-Depot, Apex, N. Y.

Apex was a typical rural station on the New York, Ontario and Western Railway on the main line in Delaware County between Cadosia and Walton. It was one of the higher points on the railroad, at an elevation of 1,462 feet above sea level. It was the railroad station for Cannonsville, five miles away, and Carpenter's Eddy, seven miles distant. An old traveler's guide states "Several beautiful lakes are in its immediate vicinity. The shooting is excellent."

Arrived Safely in Sullivan County, N. Y.

Such picturesque views were popular on postcards during the early 1900's. This view is near Winterton, New York, in a time when the O & W was very well-maintained. Note the neatly-stacked pile of ties in the left foreground ready to be placed where needed on short notice by section gangs always on the alert to keep the roadbed in top shape.

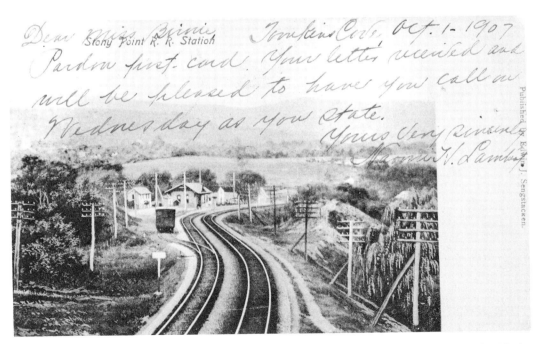

Stony Point R. R. Station

Stony Point, a place of historical importance during the Revolutionary war, is near Haverstraw on the Hudson River. This view is of the tracks of the West Shore Railroad, which was completed through this area in 1883.

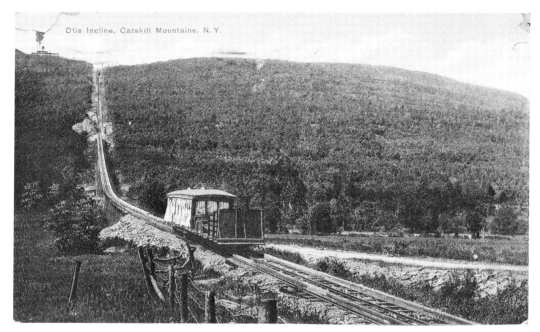

The Otis Elevating
Railway, constructed by
the Otis Elevator people,
went into service in 1892.
It offered visitors from
New York City who had
arrived for Catskill
Mountain vacations a
quick (10-minute) and
easy way to get to the
famous Catskill Mountain House, the Hotel Kaaterskill, and other resort establishments high above the Hudson River, on
which many had arrived by steamship. In *Rip Van Winkle Railroads*, William Helmer tells us that the railway was 7,000 feet
long, rose 1600 feet, and had three rails with an four-rail offset halfway on its length so that the two counterbalanced trains
could pass each other. Power was by a large Corliss steam engine at the top that moved the two-car trains (one passenger and
one baggage car) with a 7500-foot-long 1 1/4-inch-diameter steel cable having a tensile strength of 104 tons. The last service was
in 1918. The base station of the elevating railway was located about a mile north of Palenville, approximately 10 miles
southwest of the village of Catskill.

NEW GRAND HOTEL & GRAND HOTEL STATION. Catskill Mountains N.Y. *From Hugh.*

The Grand Hotel
Station, 1,886 feet above
sea level on the Delaware
and Ulster Railroad some
40 miles west of the Hudson River, served patrons of the Grand Hotel seen on the hillside in the distance, about 400 feet
higher than the tracks. This was one of the greatest Catskill mountain resort hotels; it opened for business in 1881 and could
accomodate 450 guests. According to a report from the Library of Congress quoted by Gerald Best, " . . .the management
deemed it 'The Most Modern Equipped Hotel in the Catskills.' A superior grill and rathskeller, a symphony orchestra and
weekly tennis tournaments were major attractions. The long central section with its two-storied porch provided the rocking
chair brigade with a splendid view of the countryside."

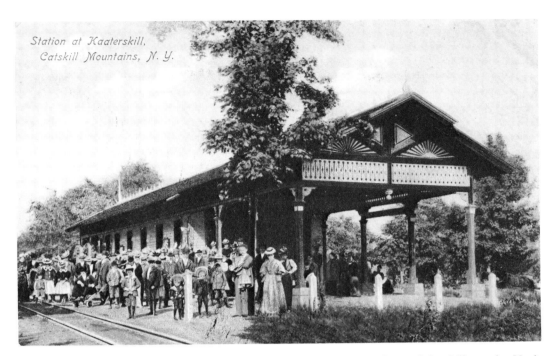

Station at Kaaterskill,
Catskill Mountains, N. Y.

The Catskill Mountain was one of several narrow (3-foot) gauge railroads that ran from the village of Catskill, on the Hudson River, to Palenville, a distance of about 15½ miles. In time, at "Otis Junction" it connected with the spectacular Otis elevating Railway which carried passengers up its 34 percent grade from the level of the Hudson River. The Catskill Mountain Railroad opened in 1883, and the Otis incline opened in 1892. The advent of the automobile spelled the end of such little operations. The C. M. Railway and its affiliates, including the Otis operation, were abandoned in 1919. The primary purpose of these lines was to serve the luxurious hotels flourishing in the Catskills during the summer months.

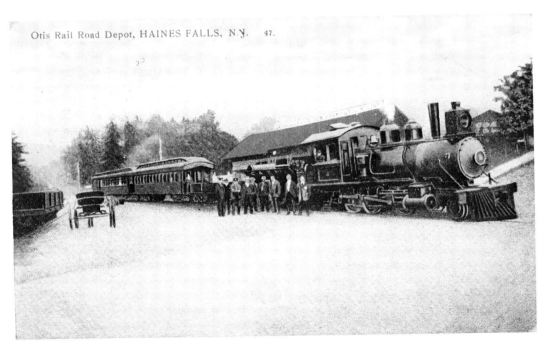

Otis Rail Road Depot, HAINES FALLS, N.Y. 47.

This rare view shows the little narrow gauge train of the Kaaterskill Railroad at Haines Falls, a "tourist stop" for many years. This 21-mile system of narrow gauge lines controlled by the Ulster and Delaware Railroad, and later by the New York Central, was opened in 1883 and abandoned in 1940. This miniature railroad started life with two locomotives, the *Rip van Winkle* and the *Derrick Van Brummel.*

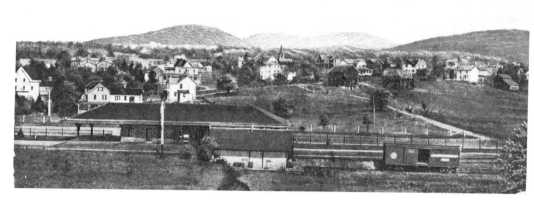

The 3-foot gauge Catskill and Tannersville was completed from Tannersville to Otis Summit in 1883 to become part of the railroad complex serving the resort hotels of the area.

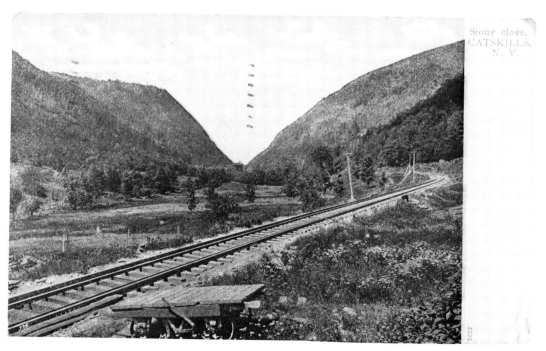

The three-foot gauge Stony Clove and Catskill Mountain Railroad was completed from Phoenicia to Grand Hotel in 1881; eventually, the line was extended to Kaaterskill with a branch to Hunter. The lines were abandoned in 1940.

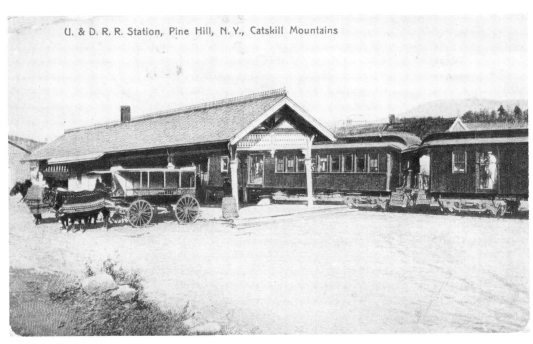

U. & D. R. R. Station, Pine Hill, N. Y., Catskill Mountains

Trains on the Ulster & Delaware stopped at Pine Hill primarily to discharge and receive passengers who patronized any of several summer resort hotels in the area, including the Guigou House, which had been taking in boarders since 1854. Postcards and photos show that most of the stations on this railroad were originally of the same design, featuring such architectural niceties as wood lattice-work gable ends and picketed ridges. Note the blankets on the horses. The car at the right appears to be fitted with a grab hook for snatching bags of mail "on the fly."

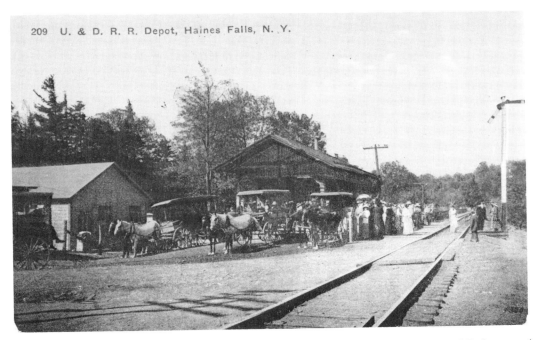

209 U. & D. R. R. Depot, Haines Falls, N. Y.

Another view of Haines Falls—this one showing the standard gauge tracks of the Ulster and Delaware. A large number of resort hotels were located within a short distance of the station; judging by the throng of passengers in this view, they were doing a "land-office" business when this photo was taken. Note the hobble-skirts that were all the rage.

RAILROAD STATION, PHOENICIA, CATSKILL MOUNTAINS, N. Y.

Phoenicia, a popular resort community, was one of the most important stops on the Ulster & Delaware. From here, the narrow gauge system went northeastward to Hunter and Kaaterskill, serving the mountain resorts of this region.

Halcottville, a resort community on the Ulster & Delaware line, is remembered as the site of a famous train wreck: a head-on collision between the *Rip Van Winkle Flyer* and the pay train on August 31, 1911. In his book on the history of the Delaware and Ulster, Gerald Best gives all the details, which are summarized by noting that the engineer of *The Flyer* was injured (and spent the rest of his career as a foreman of machinists in the Rondout roundhouse), his fireman was killed, two trainmen in the pay car were injured, and the passengers were badly shaken but none required medical treatment. Engine No 9, the 4-4-0 that hauled the first train into Oneonta in 1900, was so badly damaged that it was scrapped, but the *Flyer's* engine was repaired and placed back in service.

[editor's note of explanation for non-rail-buffs: groups of numbers like 4-4-0 refer to the wheel arrangement of the locomotive. It means there are four pilot wheels in the front, four driving wheels, and no trailing wheels; the descriptive term for this is the "American" type. A 4-6-2, by comparison, is known as a "Pacific"—it has four pilot wheels under the front of the boiler, six driving wheels, and two trailing wheels under the firebox. This nomenclature, known as as "Whyte's Classification" has a big list of different arrangements]

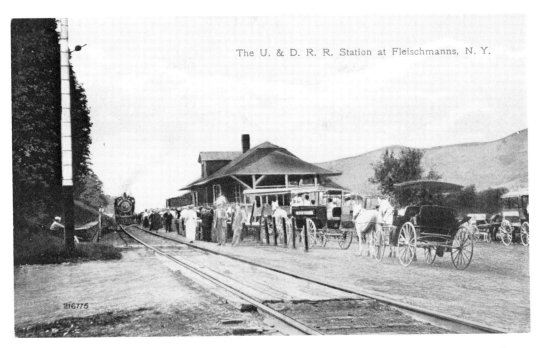

The U. & D. R. R. Station at Fleischmanns, N. Y.

Originally called Griffin's Corners, Fleishmann's came into existence in 1891 to serve the needs of summer tourists. The growth of this area was tremendous—by 1910 there were eighteen hotels here. It is said that more than 4,200 beds were available within a short distance of the depot. In the early days of the hotel industry in the Catskill mountain region, patronage was sharply divided along ethnic and religious lines. Hotels catering to Jewish patrons would note "dietary laws observed" in their printed advertising, while inns, hotels, and rooming houses desiring only a Christian clientele would state "churches nearby."

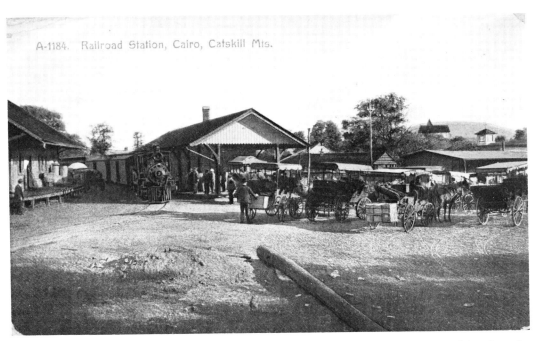

A-1184. Railroad Station, Cairo, Catskill Mts.

Deep in the heart of the Catskill narrow-gauge railroad system was Cairo. Not only was this a jumping-off point for passengers bound for the resorts, but it also provided a source of revenue from the shipment of shale rock.

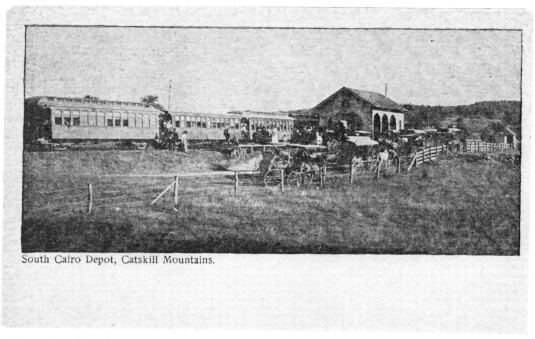

South Cairo Depot, Catskill Mountains.

South Cairo was located on the 3-foot gauge Catskill Mountain Railroad. This was a junction point where the "main line" continued on to Palenville, and a branch went to Cairo.

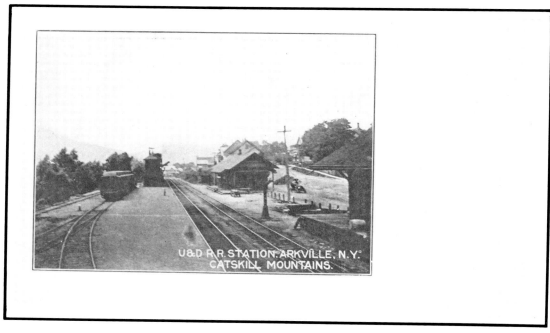

U&D R.R. STATION, ARKVILLE, N.Y.
CATSKILL MOUNTAINS.

Arkville was originally called "Dean's Corners," and is a mile-and-a-half east of Margaretville. In later years, it was a junction point with the Delaware and Northern Railroad which went southward to East Branch. Visitors to this spot today are treated to an interesting sight—it looks almost the same as this turn-of-the-century postcard view, because local community leaders worked with interested groups to develop a "tourist" line from the remnants of the Ulster and Delaware tracks and buildings. At this writing, it's possible to take a nice ride through the surrounding countryside, either on open or in closed passenger cars pulled by a diesel locomotive, or in the *Red Heifer*—a gasoline-powered railcar dating from the 1920's made by the J. G. Brill Company of Philadelphia. In turn it pulls a trailer that is the original *Red Heifer* with its engine removed. The name was tacked to the Delaware and Northern car by the locals residing along the line when it went into service years ago.

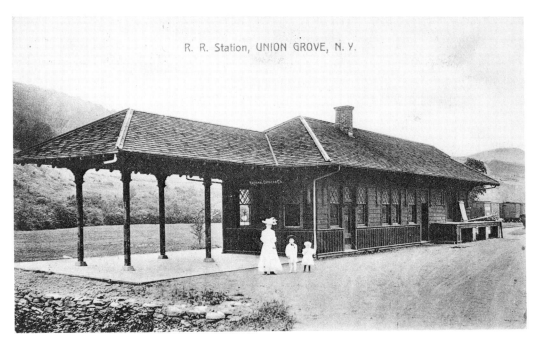

R. R. Station, UNION GROVE, N. Y.

Union Grove was a station on the Delaware and Eastern, 10 miles west of Arkville; rails reached here in 1905. This card was postmarked in 1908, so the station was very new.

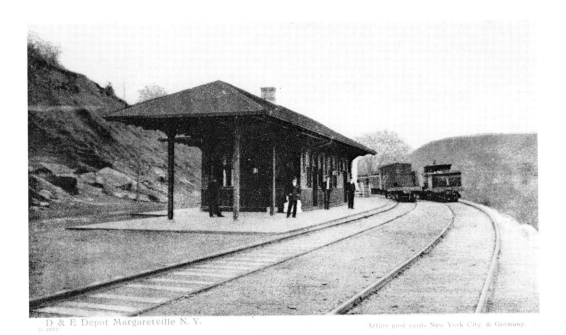

D & E Depot Margaretville N. Y.

Artino post cards New York City, & Germany.

The Delaware and Eastern, later the Delaware and Northern Railroad, was an interesting little 37½ mile shortline built from East Branch to Arkville with a branch to Andes in the Catskills. It was opened in 1906 and lasted until 1942 when it was sold to New York City for $200,000 because the city wished to flood its right of way with a new water supply reservoir behind the Pepacton Dam. It was originally intended that the line would run from Wilkes Barre, Pennsylvania, to Scotia, near Albany, where it would have connected with the Boston and Maine, but this ambitious scheme of its promoters fell far short. One of Margaretville's claims to fame was the Hotel Ackerly, later the Pocantino Inn, which accomodated 200 guests and burned in 1928—as did most of the wooden hotels in the Catskills, sooner or later.

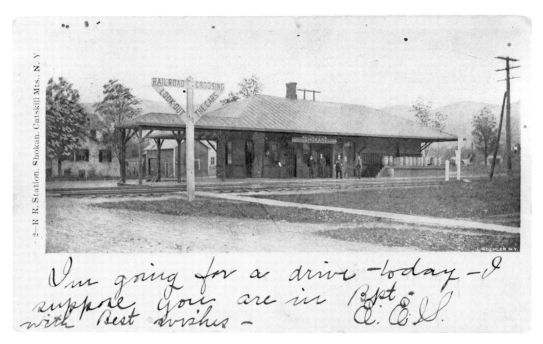

I'm going for a drive - today - I suppose you are in Bpt. with Best wishes - A. E. S.

Rails of the Rondout and Oswego, later the Ulster and Delaware, reached Shokan on September 30, 1869, the same year that the transcontinental railroad was completed with the famous "Golden Spike" ceremony joining the Union Pacific and the Central Pacific at Promontory, Utah. Shokan, 20 miles west of Kingston, prided itself in being called "the gateway to the Catskills."

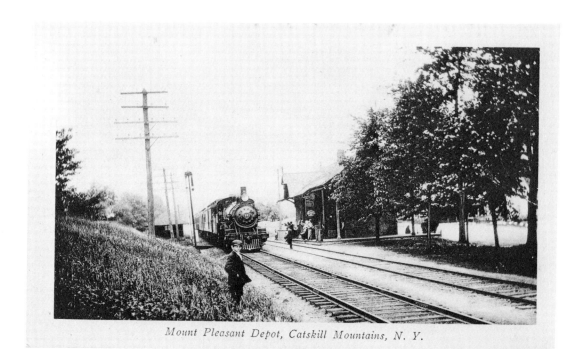

Mount Pleasant Depot, Catskill Mountains, N. Y.

Mt. Pleasant Station was another stop on the Ulster & Delaware as it wended its way through the Catskills. Tracklayers reached this point in March, 1870 when the line was still called the Rondout and Oswego. Over the years, the U & D was often referred to as "Rip Van Winkle's Railroad." Note the fresh and manicured appearance of the ballast and right-of-way as befitted a time when the road was new and all hands took pride in keeping everything neat and tidy and little boys wore suitcoats and visored caps.

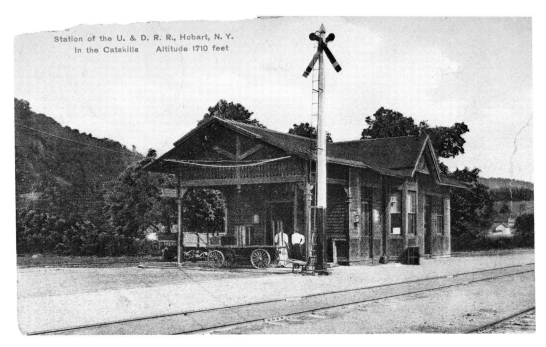

Station of the U. & D. R. R., Hobart, N. Y.
In the Catskills Altitude 1710 feet

The village of Hobart is three-and-a-half miles west of Stamford. The railroad was completed to this point, at the foot of Cornell Avenue, on December 1, 1884. Years ago Sheffield Farms had a large operation here which provided a lot of business for the railroad. The station has almost a "Swiss Chalet" appearance, perhaps to impress New York City residents who in those days might well have considered a building at 1710 feet above sea level practically in the stratosphere. The Ulster and Delaware had its hands full moving heavy trains 108 miles over the mountains between Kingston Point on the Hudson River at sea level and its western terminus at Oneonta, and was forced on plenty of occasions to rely on two steam engines pulling and a third pushing from the rear to accomplish the task. The high point of the line was Kaaterskill Junction, at 2150 feet, and one of the heaviest grades—3.20 percent—was just to the east between there and Big Indian.

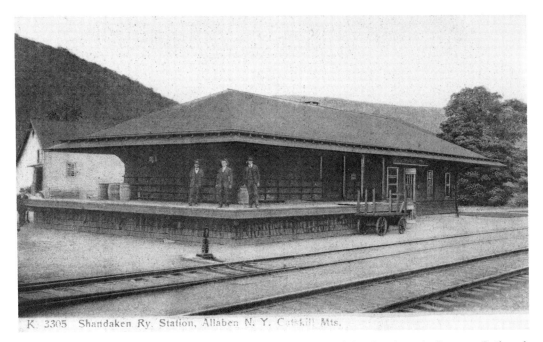

K. 3305 Shandaken Ry. Station, Allaben N. Y. Catskill Mts.

Allaben was named for Orson M. Allaben of Margaretville, one of the original directors of the Rondout & Oswego Railroad, which ultimately became the Ulster & Delaware.

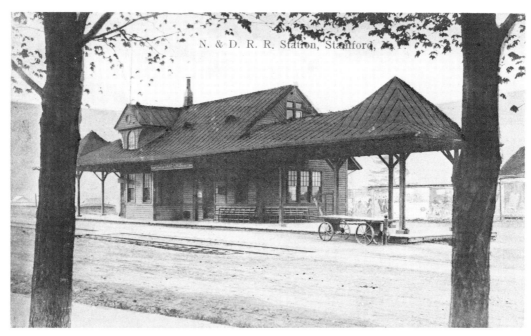

"Teddy Roosevelt Slept Here" might read a sign as one enters Stamford, on the western slope of the Catskills. One of the first trains over the line carried the future President Theodore Roosevelt, who stayed at the Delaware House on June 25, 1883 when he was a New York State Assemblyman. Stamford is a picturesque village overshadowed by Mt. Utsayantha. In its day Stamford's largest hotel, Churchill Hall, was unrivaled anywhere in the region for its elaborate accomodations.

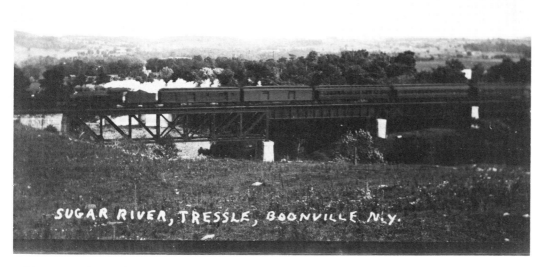

This view showing a "tressle" helps to prove that producers of postcards, like book publishers and sign painters, find their mistakes, spelling goofs, and typographical errors the instant the finished product is put before to the public and not a second before. Boonville was a major stop on the New York Central's St. Lawrence division, originally built as the Utica & Black River Railroad, and the major rail route between Utica and Watertown. The Sugar River is one of many streams crossed by the railroad on high bridgework.

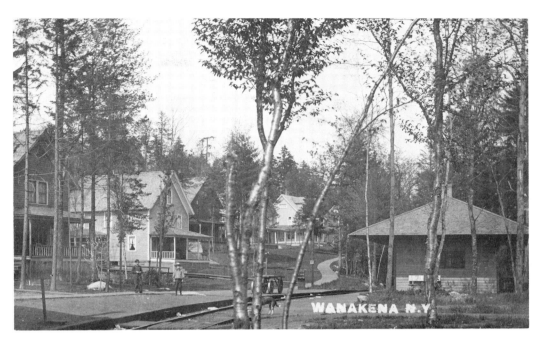

Wanakena, a small community on the west side of Cranberry Lake in the Adirondacks, was the terminus for the Cranberry Lake Railroad, which connected with the New York Central at Benson Mines. It was six miles long and opened in 1903, primarily as a logging road. It operated until 1914. For many years the New York State Ranger School has been located here.

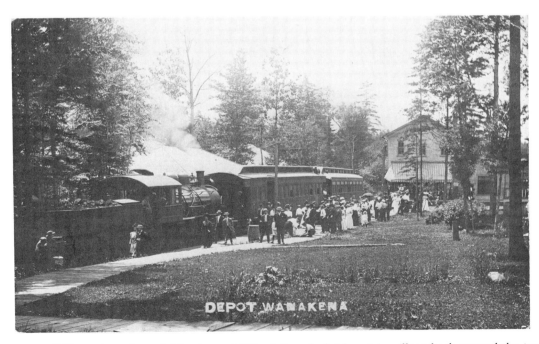

Still another view of this pleasant little Adirondack Mountain village back around the turn of the century.

R. R. STATION, BOONVILLE, N. Y.

Trains bound for Ogdensburg and other North Country parts passed through the agricultural community of Boonville on a daily basis in the old days. The 1905 timetable lists five northbound and seven southbound trains each day, so this station was a busy place. Passenger service ended here in 1961, and that portion of the "Hojack" line north of Lyons Falls, to Lowville, was torn up in 1964.

Depot and Boat Landing, Old Forge, N. Y.

The Old Forge depot was at the end of a 2-mile spur line that connected with the New York Central's Adirondack division at Thendara. The branch was constructed in 1896 as a convenience to the local hotels and resorts and operated until the summer of 1932 when it was abandoned.

Faust is merely another name for what used to be Tupper Lake Junction, established in the early 1890's as an interchange point between the Mohawk & Malone and Ottawa divisions of the New York Central. Passenger service was discontinued to Tupper Lake in 1964 while the Ottawa line, to the left of the picture, folded in 1937. The station at the right was demolished in the early 1970's. A stub line left the main line at this point and went to the village, about a mile-and-a-half east of the station.

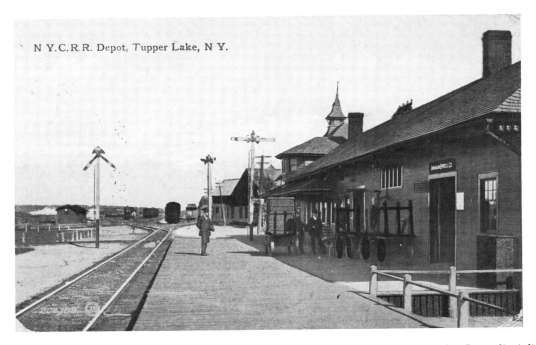

A person's-eye view of the Faust station platform. This was one of the busiest points on the Central's Adirondack division, and it had an engine house as well as other servicing facilities.

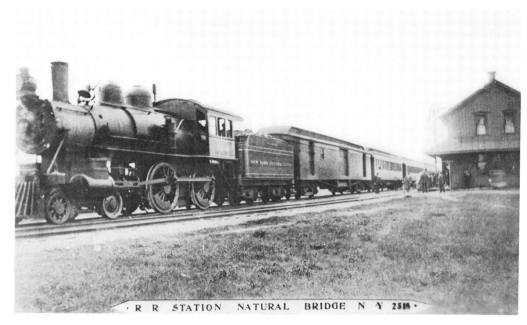

·R R STATION NATURAL BRIDGE N Y 2516·

This rare postcard view features the famous New York Central locomotive "999" which set a world's speed record in 1893 by going 100 miles per hour for a considerable distance in what was to a large extent a publicity stunt to get attention from the news media. Here it has been degraded to performing more normal duties pulling the local passenger train between Newton Falls and Carthage on the New York Central's Carthage and Adirondack branch. Natural Bridge is a few miles east of Carthage. "999" was relegated to branchline duties after being rebuilt to run at more normal speeds than that achieved in the run that brought it fame a few years earlier.

New York Central Station, Carthage, N. Y.

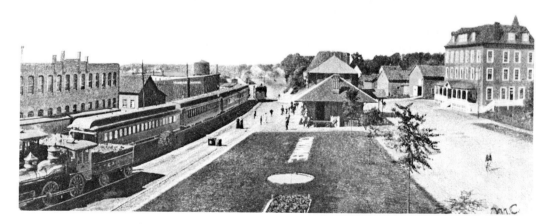

Carthage was an important junction point on the New York Central's St. Lawrence division, and thanks largely to its papermaking industry, provided plenty of business for the railroad. Trains diverged here and went to Watertown, Ogdensburg, or Newton Falls. A small shortline railroad called the Carthage & Copenhagen operated from here between 1906 and 1918.

The engine at the lower left is somewhat of a mystery, because it appears to be a much earlier type than the Central would have been operating here at the turn of the century, and it's most unlikely that they operated any engines with a four-wheeled tender at this time, or anytime, for that matter. Perhaps it has been "faked" in the picture by an artist with limited knowledge of railroad matters, or it might be an engine operated by a local paper mill. Perhaps a reader can answer the question.

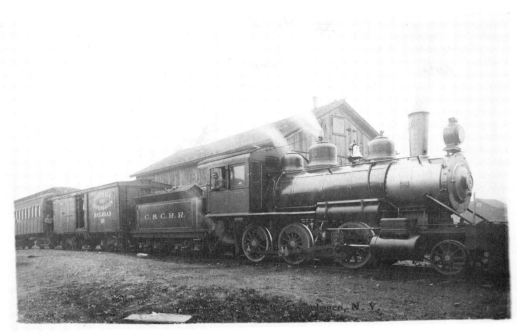

This little type 2-6-0 engine was built by Vulcan in October, 1908 and was purchased new by the Carthage & Copenhagen. Shown in the cab is engineer Charles Colgrove.

N. Y. C. R. R. Station, Pine Camp, N. Y.

Pine Camp, near Watertown, was established in 1908 as a maneuvering ground for regular U.S. Army and National Guard troops. In order to bring men for training from ten Army posts and their homes throughout eight northeastern states, the New York Central constructed a spur from the Carthage-Philadelphia line, and the Watertown Daily Times of June 1, 1908 says: "Work was rushed in the building of a railroad spur and a gang of Italian laborers were working all day, building a railroad spur on Pine Camp etc. etc." So many men were engaged in summer maneuvers that thirty troop trains were required to bring them. (Let's hope they didn't all try to use that little out-house at the same time.) An early timetable advises that between June 15 and July 15 (when the troops were present) special one-day tickets were available for 25 cents round trip between Pine Camp and Carthage, with 65 cents being the ante for the Pine Camp-to-Watertown-and-return jaunt. In 1940, when we were starting to concern ourselves with World War II, a garrison was established and the name was changed to Camp Drum and later, Fort Drum—after General Hugh A. Drum. As this is written, an enormous expansion of the facility is taking place that will have a tremendous economic and social impact on the entire region of the state as large numbers of troops and their families take up permanent residence.

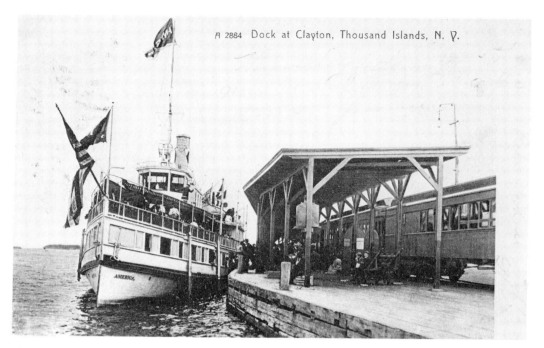

A 2884 Dock at Clayton, Thousand Islands, N. Y.

One of the most important stations on the New York Central in the "North Country," particularly during summer months, was Clayton. Here, long passenger trains met steamboats that took travelers to various points on the Thousand Islands in the St. Lawrence River.

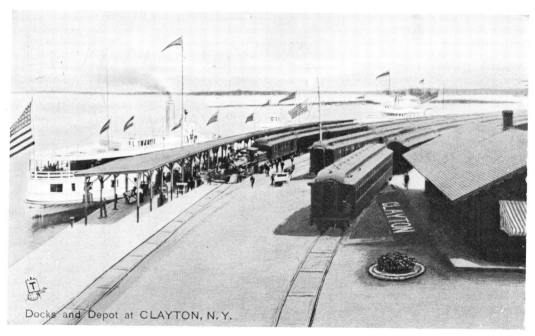

Docks and Depot at CLAYTON, N.Y.

This view gives a better perspective on the immense business the New York Central once had to the Thousand Islands before World War I. Passenger service to Clayton was discontinued in 1951, and the line was abandoned in 1973.

This old depot at Sackets Harbor, originally on a branch of the Rome, Watertown and Ogdensburg Railroad, still stands and houses a fine restaurant. It was erected in 1888 after fire destroyed the original depot. The eight-mile branch line from Watertown was completed in 1872. Sackets Harbor was first reached from Pierrepont Manor via the 18-mile Sackets Harbor & Ellisburgh Railroad in 1953, but this short line was abandoned after only a decade of use.

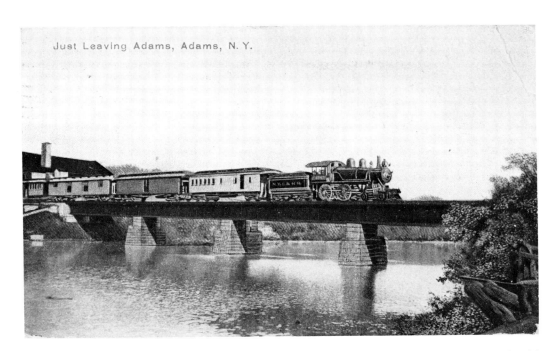

A southbound passenger train on the New York Central's "Hojack" line passes over the north branch of Sandy Creek at Adams in Jefferson County. At this point the creek is more in the nature of a river. Pulling the train is one of the Central's distinctive "Buchanan Class" 4-4-0 locomotives that pulled fast main line trains in the 1890's; the "999" (see p. 98) was one of these. By the mid-1900's they had been replaced by larger locomotives and were relegated to branch line duties for the rest of their days.

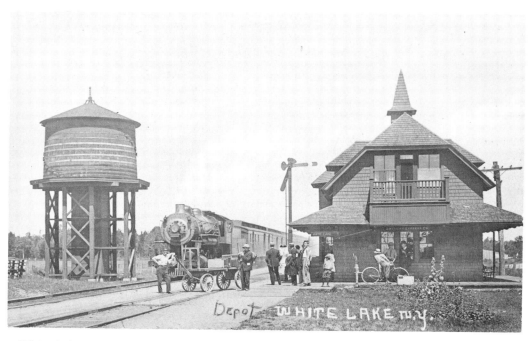

White Lake, near Forestport, was on the Adirondack division of the New York Central. Built in 1892, the line was promoted as the "Golden Chariot Route" but to most of the locals, it was the "Mohawk & Malone." In those days, the agents and their families lived upstairs in the stations, as is suggested to be the case here by the lace curtains in the window.

The Saranac Lake Station shows its obvious Delaware & Hudson heritage. It was built in 1903, and was used jointly by the D & H and the New York Central, thus the term "Union Station" on the card. The Central purchased the line from Lake Clear Junction to Lake Placid in 1946. Passenger service was discontinued on April 24, 1965. Luke Wood of Gabriels was the last agent.

This unusual-looking station with accompanying trainshed in Malone was completed by the Ogdensburg & Lake Champlain Railroad in October, 1865, and served the Rutland Railroad until the end of passenger service in 1951. The trainshed has been demolished, but the two turrets are still used as offices. The railroad's machine shops were also located here, together with a 12-stall roundhouse.

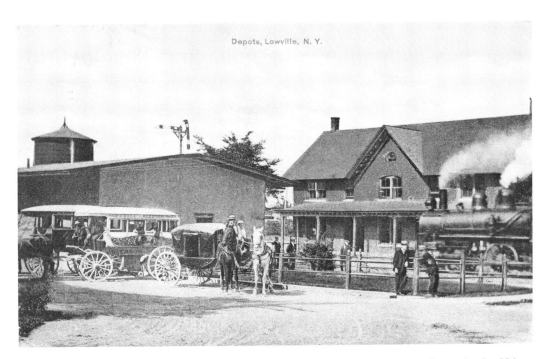

Lowville was a busy and prosperous little community on the New York Central's St. Lawrence Division, formerly the Utica and Black River Railroad. Overnight passenger trains operated between Utica and Ogdensburg over this route. The building at the right, the original station, featured a restaurant for passengers.

The writers considered using "When Horses Met the Trains" or "When Horses Met the Iron Horses" as the title for this book, having been inspired by scenes such as this when doing their research.

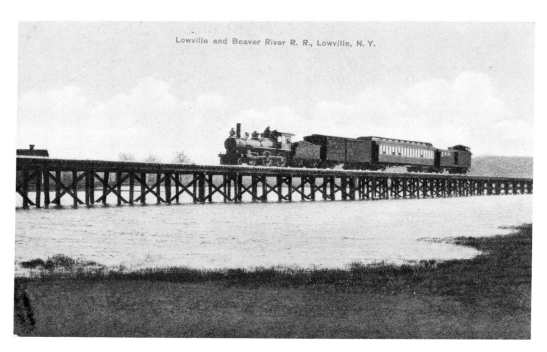

A favorite place for photos was this long trestle on the Lowville & Beaver Railroad in northern New York. In spite of truck competition, this shortline has managed to survive for more than eighty years, although small diesels have long since replaced the "glamorous" steam locomotives. The mixed train in the photo is being pulled by No. 10, a 4-4-0 built by the Schenectady Locomotive Works in 1870; it was purchased second-hand from the Adirondack Railway.

Rail buffs are always cheered by the knowledge that another steam locomotive has eluded the scrapper's torch; an example is Norwood & St. Lawrence's No. 210, which has found a permanent home at Steamtown, U.S.A. in Scranton, Pennsylvania. The engine was built in 1913, and served the St. Regis Paper Company for many years. This dandy piece of machinery had an especially narrow escape, for it was once sold for scrap.

INDEX